EVERY 17 SECONDS

A GLOBAL PERSPECTIVE ON THE AIDS CRISIS

Brian Weil

Introduction by
Simon Watney

Aperture

Aperture gratefully acknowledges the generous contributions of those who care in these times of crisis. Without the financial support of the following people, Every 17 Seconds: A Global Perspective on the AIDS Crisis would not have happened:

CORNELL CAPA

CHARLES CELIAN
 IN FOND MEMORY OF ANGUS MACMILLAN

RONALD AND FRAYDA FELDMAN

LYNNE AND HAROLD HONICKMAN IN LOVING
 MEMORY OF THE EXTRAORDINARILY CREATIVE
 LIFE FORCE OF MICHAEL F. K. KNAPP:
 APRIL 26, 1953–APRIL 1, 1992.

BERTON AND SALLY KORMAN

JANE AND LEONARD KORMAN

MARK LEVINE

BARNABAS MCHENRY

ROBERT MILLER AND
 BETSY WITTENBORN MILLER

WILLIAM A. AND BEVERLY R. ROSOFF
 IN TRIBUTE TO BARBARA ROSOFF — WHO
 HAS DEVOTED HER LIFE TO THE ARTS.

CARL STEELE AND ASSOCIATES, INC.

VISION GALLERY, SAN FRANCISCO

DEDICATION

This book is dedicated to Maria, Flavia, and
Fernando Barcellos in loving memory.
Most importantly this book is for Adriana,
in hopes that one day it will help her
to understand.

ACKNOWLEDGMENTS

I would like to thank the following organizations for their
generous support: Agfa Division of Miles Inc.; Art Matters;
Exit Art; the Nathan Cummings Foundation; the AIDS
Foundation of St. Louis; Earl Millard Fund-Grants; the
New York State Council on the Arts; the W. Eugene Smith
Fund; the Andy Warhol Foundation for the Visual Arts, Inc.;
as well as Photographers + Friends United Against AIDS;
the International Center of Photography; and Aperture.

I would also like to thank the following individuals: Patti
Cummings, Buzz Hartshorn, Dr. Glen Margo, Betsy and
Earl Millard, Eelco Wolf, Philip Yenawine, Simon Watney,
Donald Moffett and Marlene McCarty at Bureau, my editor
Melissa Harris, and my parents for a lifetime of support.

A very special thanks goes to Ann Philbin. Her love,
strength, and wisdom have been my comfort in a too-
often painful world.

Seeing AIDS: The Work of Brian Weil. By Simon Watney

In one sense, photographing AIDS (acquired immunodeficiency syndrome) is an impossible ambition. No single photographic strategy or technique could possibly reveal the constantly shifting mass of information, patterns of infection, rates of disease progression, governmental action (and inaction), and community response, let alone the "human face" of a tragedy of such dimensions. There is also a personal dimension for the artist that is rarely discussed, for to photograph AIDS involves constant exposure to the most harrowing experiences and a seemingly intractable set of problems. This inevitably produces reactions of sorrow, of anger, of dread, of pity, and of helplessness. And the photographer (or filmmaker, or writer) has somehow to live his or her most private emotions in the full glare of public scrutiny, in order to direct attention to the issues surrounding AIDS as they are manifested in a multitude of circumstances, which, apart from AIDS, would seem to have little or nothing in common.

Nonetheless, the experience is perhaps salutary, since the more one learns about one's own difficulties in focusing constantly on AIDS, the better one is able to understand why so many people prefer not to look at all. The great virtue of the remarkable body of work produced since the mid 1980s by the young, New York–based photographer Brian Weil seems to me to be the modest yet success-

INTRODUCTION

ful way in which his images help us to understand AIDS as both a personal issue of terrible intensity, and a public issue concerning political will. Unlike Weil, however, most photographers present the epidemic very much from within the established conventions of documentary practice, so that until now, our understanding of AIDS has been primarily confined to two sets of imagery. Firstly, there are technologically generated images, which concentrate on the immediate clinical signs and symptoms of HIV (human immunodeficiency virus), and on the look of HIV—gigantically enlarged by electron microscopy. This high-tech vision of science and scientific research does not, however, provide a sense of the powerful mediating institutions and their players—the hospital administrators, or civil servants, or government officials, or stock-exchange brokers—who, for better or for worse, have a major role in determining the policies on which so many lives currently depend.

Secondly, there are images of faces and bodies, graphically marked by signs of extreme illness and suffering, and a domain of science on which we are encouraged to pin our hopes for "the cure." It has frequently been pointed out that such photographs repeatedly depict people with AIDS as isolated, often in a hospital or hospice setting, often close to death.[1] We rarely see people with AIDS in groups, or as

part of the ordinary, everyday world of work and leisure. Ultimately, such photographs only collude with a wider climate of fatalism, which is profoundly disempowering for people living with HIV or AIDS. Hence the demand by ACT UP (AIDS Coalition To Unleash Power) and others that we see counterimages showing people with AIDS not as "victims," but as "vibrant, angry, loving, sexy, beautiful, acting up and fighting back."[2]

The bodies and faces that we are relentlessly shown convey a heavy ideological message, which resides mainly in the routine repetition of certain types of imagery, and in equally systematic omissions. In this way, a "common sense" of AIDS has been widely established, according to which we accept people with AIDS as the objects of medical scrutiny and intervention, but rarely think of them as active subjects, people who have played a central and often historic role in challenging bad policies and helping to devise better ones. We have arrived at a gruesome "picturesque" of AIDS, with a well-established iconography and dramatis personae, as well as a singular plot line that leads, inevitably, toward an imminent death.

Both photojournalism and documentary practice have played a significant role in establishing and reinforcing this "picturesque" and, therefore, a wide range of popular misconceptions and misunderstandings about AIDS, often doing so in such a manner as to cast blame on specific groups of people, rather than revealing unsafe practices that may put us at risk. Thus, the possible risk of HIV infection is frequently considered to derive directly from intravenous drug use, or prostitution, or homosexuality per se, rather than from sharing needles and syringes, or from unprotected sexual intercourse. Those who were affected first, in the years before AIDS was even identified as a distinct syndrome, still often are thought to be responsible for the epidemic. Subsequently, AIDS continues to be presented as a problem for "other people," a nightmare that is unlikely to affect "us" (that is, heterosexuals) directly.

This kind of ignorance is also evident in the media's seeming obsession with the most obscure and bizarre modes of HIV infection, and their disregard for everything that is clearly understood about transmission. As a result, many viewers are easily persuaded that they are not really at risk, and that, in any case, there is nothing they can or should do on their own to protect themselves. Along with sensationalizing HIV, such media commentary stubbornly refuses to learn anything from HIV education, which has been demonstrably effective in communities that have been living with AIDS throughout the 1980s and into the '90s. Effective safer-sex education around the world has been based on the simple recognition that safer sex is an issue for anybody having sexual intercourse, whether anal or vaginal, regardless of their known or perceived HIV status. The media, however, frequently perpetuate the claim—particular to Britain and America—that *all* responsibility for HIV infection resides with those who know they have been infected.

In reality, of course, relatively few know their HIV status for sure, either because they have not taken an HIV antibody test or because they have had unprotected sex after testing negative. By placing all responsibility for HIV transmission on people who know they have HIV, many heterosexuals appear to believe they are absolutely not at risk. What we are dealing with here is resistance to acknowledging the realities of the epidemic, resistance that is often culturally cemented and sanctioned. By construing people with AIDS as culpable victims of their own "immorality," many influential commentators unfortunately lull people into complacency and encourage bigotry. Vast sums of money and energy have been squandered on research projects that start from the assumption that only certain kinds of people are likely to have unsafe sex or share needles. Such projects, therefore, do not take into account the influence of perceived gender roles on sexual behavior or the methods of, and financial constraints on, medical practice in some Third World countries, which might preclude the use of condoms or clean needles. As for the "developed" world, anyone can have unsafe sex, for a variety of reasons that may easily change over time. And those who share needles or syringes generally do so for the grim reason that clean "works" continue to be systematically denied them.

From a European perspective, the continued refusal of the United States to implement needle exchanges is the most obvious evidence of a society in a state of literally murderous denial. Even in Margaret Thatcher's Britain the political rhetoric of a "war on drugs" did not prevent the implementation of needle exchanges throughout the country, since the government recognized early on that HIV presents a far more serious threat than IV-drug use. Visitors to the United States from all around the world continue to be variously bewildered and appalled by the extraordinary argument that AIDS education (of all things!) is somehow likely to promote "promiscuity" and to seduce the masses into overnight heroin addiction.

Perhaps the most prevalent fantasy about AIDS on the part of heterosexuals is that all over the world gay men have witnessed their friends and loved ones dying in droves around them, and that this has been the major incentive behind the shift to safer sex. While it would be difficult to overstate the impact of AIDS in Manhattan or San Francisco, these are anomalous—not typical—situations. For example, the United Kingdom has a population of approximately sixty million people and it remains statistically unlikely that the majority of gay men in Britain have ever knowingly even *met* someone living with AIDS. This is very much the case in most parts of the world. If safer-sex education has been successful among gay men, it is not because of some imagined "proximity" of death on a vast, directly experienced scale. On the contrary, it has been a *cultural* achievement, moored in notions of community development and solidarity. Ironically, the models of safer-sex education and of community care that prevail in most Western democ-

racies derive from American experience — experience that continues to be tragically ignored by the American government and its many agencies.[3]

Most people all around the world continue to see AIDS not by direct experience, but through sources such as newspapers and television. Hence the profound significance of visual imagery, as it largely determines most people's perceptions of *all* aspects of the epidemic, from health promotion to questions of discrimination, prejudice, care, treatment, and service provision. This is the proper context in which we should consider Brian Weil's work. Brian's pictures hardly provide easy answers. On the contrary, their deliberate graininess slows down our perception, making us work to read the image. While he does not shirk the difficult issue of pain, his photographic stance is neither clinical and detached, nor in any way sentimental. We see people "living with AIDS," a process which for many includes the social as well as the physical fact of death, both for the sick and for their care givers.

Wherever we may live, we are likely to think of AIDS in local terms. Thus, for example, the epidemic in downtown Manhattan is very different from the epidemic as it is lived in Brooklyn or Queens, just as the epidemic in Edinburgh had a very different face from the epidemic in London. In other words, we are not simply dealing with "an epidemic," but with many different epidemics, unfolding at different speeds within different population groups according to differing local factors. In some areas of Manhattan the epidemic has been overwhelmingly concentrated among gay men, while elsewhere in New York it has had an equally disproportionate impact among black and Hispanic drug users and their sexual partners.

Again, it needs to be emphasized that the disproportionate impact of AIDS in these marginalized communities is a direct reflection of the denial of effective health education and other facilities to those most at risk, who should have been identified from the very beginning of the epidemic as having the greatest entitlement to education and service provision. Standards of care and patient management vary dramatically within most countries as well as between different countries, and this is almost always directly connected to failures in central planning, funding, education, and health care. These discrepancies may be mapped most accurately and tragically in terms of the differing patterns of life expectancy after diagnosis for different groups of people with AIDS. For example, it is widely recognized that women with HIV tend to be diagnosed later in the course of their illness than men, hence the tendency for men to live much longer with AIDS than women do. In this, as in so many other respects, AIDS tends to shed an especially bright light onto the failings of most national health-care systems in the developed world.

Local and national health-care issues also possess an international dimension, for the provision of treatment drugs is dependent on the research policies of the multinational pharmaceutical industry. Many

aspects of AIDS—from travel and immigration policies to the availability of treatment drugs—are dependent on international social, political, and economic factors. These in turn have a direct impact on the quality of life, and the life expectancy, of people with AIDS in different parts of the world, as monitored by the World Health Organization. AIDS has already had a devastating impact throughout Central and Western Africa, affecting both the rural agrarian populations and their economies, and the urban educated middle class. A similar impact is also well under way in large areas of South America and East Asia.

How then can one begin to photograph an epidemic? As Brian Weil himself has pointed out: "To document AIDS is an amazingly presumptuous thing because the scope of the epidemic is so complex and diverse. Dependent on the character of each particular culture, the disease manifests itself in different ways."[4] Working over time, and across international boundaries, Brian has produced a body of work that helps us understand something of the complexity of issues raised by the epidemic around the world, issues that are constantly changing as the epidemic worsens, and as our knowledge and understanding develop. He enables us to place our local experience in the wider national and international context. Instead of seeing threatening "others," we see differences *and* similarities, and become aware of *our* differentness from the perspective of other cultures and societies.

We must establish the wider picture to see connections, to sense the epidemic in its global aspects. This need not involve total fatalism. But it is surely grossly naive to imagine that we can ever see AIDS without being obliged to pay close attention to human agony on a massive scale.

The point is that we must try our best to do justice to the irreducible nature of the personal experience of illness, without totally abstracting this away from the wider social, political, and economic context in which the epidemic is always lived. There is little point in trying to create the illusion (in the manner of traditional humanist photo-documentary practice) that AIDS is a totally uniform experience that manifests itself similarly around the world. At the same time, however, it seems equally important not to deny our common human frailty and vulnerability to disease in general. Though it is imperative to attempt to demystify AIDS, and to try to explain the stupidity and plain wickedness of many politicians and others who have attempted to hijack the epidemic for their own purposes, it is equally important to provide people with the rare opportunity to identify with people with AIDS, people very much like ourselves.

The question of sympathy strikes me as absolutely fundamental to an improved understanding of AIDS, because for so long people with AIDS have been depicted as though they were creatures from another planet. The complaint that photographers have tended to individualize AIDS has some truth, but it is ultimately naive if this is meant to imply an embargo on the sight of human suffering. Indeed, I can think

of no single issue that cries out for greater emotional honesty and truthfulness. For we do not see policies, we see people. As long as the majority regard HIV as if it were a symptom of "otherness," few will behave responsibly, and many will continue to be placed at increased risk of avoidable infection.

Brian's photographs do not dwell on the outward manifestations of AIDS, but neither do they ignore or suppress the brutal realities of illness and death. They are not coy or euphemistic about safer-sex education. If we did not care about sexual pleasure in our own lives, we would not be so concerned about sexual health. Looking through these pictures for the first time in Brian's studio, I suddenly recalled a young, black primary-school teacher from Washington, D.C. who spoke at the Fifth International AIDS Conference in Montreal in 1989. She was charged with the difficult responsibility of providing HIV education for her pupils. She recounted how, during one class, after the natural history of the virus had been explained, and the children's questions had been explored, one little girl put up her hand for a final, hesitant question. "Does AIDS hurt?" she had asked. In the massive torrent of words and images that claim to deal with this epidemic, the one, basic, sympathetic question has rarely been touched on. Brian Weil's photographs help us to learn something of the full, terrible extent to which AIDS does indeed hurt. Not simply because of clinical disease, or as the unintended consequence of treatments, but as a result of all the fear, and ignorance, and prejudice surrounding the whole epidemic. It is that thick carapace of preconceptions and misconceptions that Brian's work manages to cut through, helping us in the difficult but necessary task of seeing AIDS. We may pretend for the time being that AIDS is not the future, but such self-deception is likely to cost us all dearly. As George Eliot pointed out long ago, in one of the most powerful paragraphs in English fiction:

> Some discouragement, some faintness of heart at the new real future which replaces the imagery, is not unusual, and we do not expect people to be deeply moved by what is not unusual. That element of tragedy which lies in the very fact of frequency, has not yet wrought itself into the course of mankind; and perhaps our frames could hardly bear much of it. If we had a keen vision and feeling of all ordinary human life, it would be like hearing the grass grow and the squirrel's heart beat, and we should die of that roar which lies on the other side of silence. As it is, the quickest of us walk about well wadded with stupidity.[5]

Most people in the developed world still think of AIDS as an exotic phenomenon, horrifying, yet somehow not really likely to affect them directly, personally. However, as cult figures and popular heroes like basketball and tennis stars Magic Johnson and Arthur Ashe come forward with the news of their HIV

infection, we are forced to recognize that our "us" and "them" distinctions are as false as they are dangerous and bigoted. Perhaps the jolt of such news will bring the reality of AIDS home to many, and this, as well as powerful, humane, and truly honest images such as those by Brian Weil, will help us to see AIDS as something far from unusual. There is no inevitability about the future course of this epidemic. AIDS is not necessarily our destiny. But we can only avoid greater devastation if, even at this late hour, we can help people see a reality that has been more systematically mystified and obscured than any other global crisis in modern times.

If this epidemic is to be stopped in its tracks, as it must be, we must somehow learn that a virus cannot be contained by fiat. This, then, is our challenge: to re-educate people, in part through photographs such as Brian's, and to undo the untold damage caused by voyeuristic and sensationalist reporting (both visual and written) and by the callous rhetoric of moralistic dogmatism. Unless we can help people identify this tragedy as one that indeed lies "in the very fact of frequency," that frequency is ever more likely to overwhelm us all.

Notes

1 For example, see Jan Zita Grover, "Visible Lesions: Images of the PWA," *Afterimage*, vol. 17 no. 1, Summer 1989; Simon Watney, "Representing AIDS," in *Ecstatic Antibodies*, ed. T. Boffin and S. Gupta (London: Rivers Oram Press, 1990); Watney, "Photography and AIDS," in *The Critical Image*, ed. C. Squires (Seattle: Bay Press, 1990); and Douglas Crimp, "Portraits of People with AIDS," in *Cultural Studies*, ed. L. Grossberg, et al. (New York: Routledge, 1991).
2 From an ACT UP handout, New York, 1988.
3 See Watney, "Safer Sex as Community Practice," in *AIDS: Individual, Cultural and Policy Dimensions*, ed. P. Aggleton, et al. (London and New York: Falmer Press, 1990).
4 Willis Hartshorn, "Interview with Brian Weil," in Brian Weil, *The AIDS Photographs* (New York: International Center of Photography, 1991), n.p.
5 George Eliot, *Middlemarch* (1871–72), (Harmondsworth, UK: Penguin Books, 1981), p. 226.

AIDS was not something that I initially sought to photograph. But as more and more of my friends got sick, the need to confront the subject became powerfully and urgently apparent to me. In 1985, I began working with the Gay Men's Health Crisis (GMHC), and that is how I met Maria.

Maria was a graduate student, and her husband, Fernando, a professor. When he was diagnosed with AIDS, they left New York and returned to his home in Brazil with their one-year-old daughter, Flavia. When the baby also became ill, they decided that Maria and Flavia must return to the United

MARIA

States for care, as there was virtually no treatment for people with AIDS in Brazil. At that early stage, the minimal treatment available in the United States was Flavia's only hope for a prolonged life. Fernando was visibly sick at this point and was not allowed to come with them, as new immigration laws, instituted by United States Attorney General Edwin Meese, restricted people with AIDS from entering the country. Soon after her arrival in New York, Maria tested positive for HIV; around this time, she also discovered that she was pregnant.

In the mid '80s, the services available for women and children with AIDS were still marginal in the United States. GMHC set up a training program to teach people who wanted to help women and children with AIDS how to coordinate and utilize the various medical and social services available to

them. It was through my involvement in this program that I became, in GMHC's term, Maria's "buddy."

There were several immediate crises for us to confront together: Flavia was suffering from severe neurological disorders that made her unable even to sit up in her stroller. Basic needs, like getting her a special chair and stroller, meant going through the public health system's bureaucratic nightmare. Flavia died before the paperwork was finally processed and approved.

While this was going on, there was also Maria's pregnancy to think of. At that time, it was thought that 50 percent of children born to HIV-infected mothers would be born with the virus (it is now estimated that the rate of transmission is 15–30 percent). Maria's religious beliefs made abortion a devastating option for her, and she desperately wanted to talk it over with a priest. It took six months to find a priest who would agree to speak with Maria about the possibility of terminating the pregnancy.

Eventually, having decided to keep the baby, Maria agreed to be part of a research protocol involving HIV-infected women. Because of her participation, she was given exceptional prenatal care. About five months into her pregnancy, she was hospitalized in a maternity ward with AIDS-related pneumonia. None of the nurses had treated a woman with AIDS before. Their response to Maria's illness was to put a sign on her door that read "Infec-

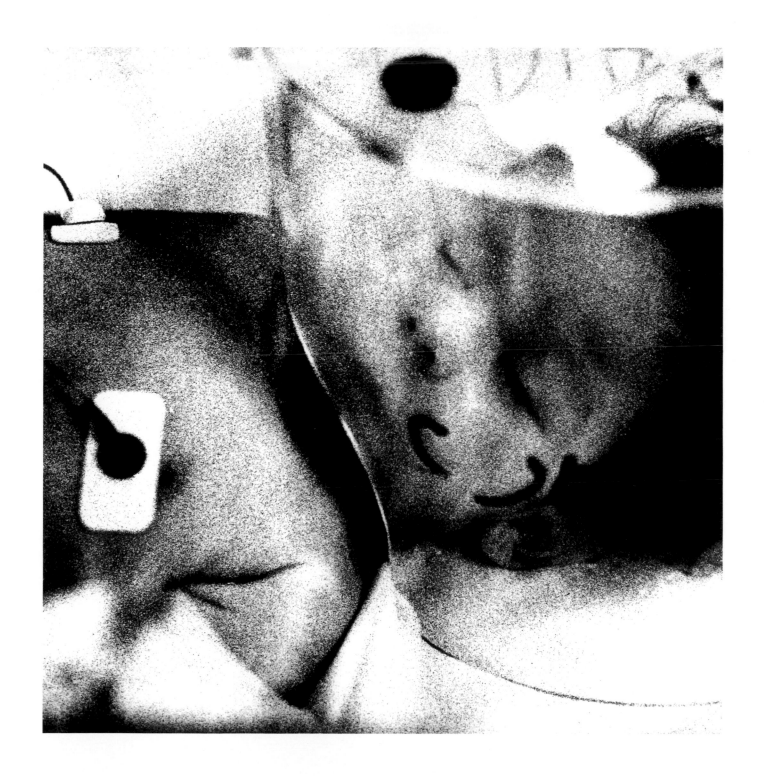

FLAVIA BEFORE HER DEATH AT TWO, Brooklyn, NY, 1985

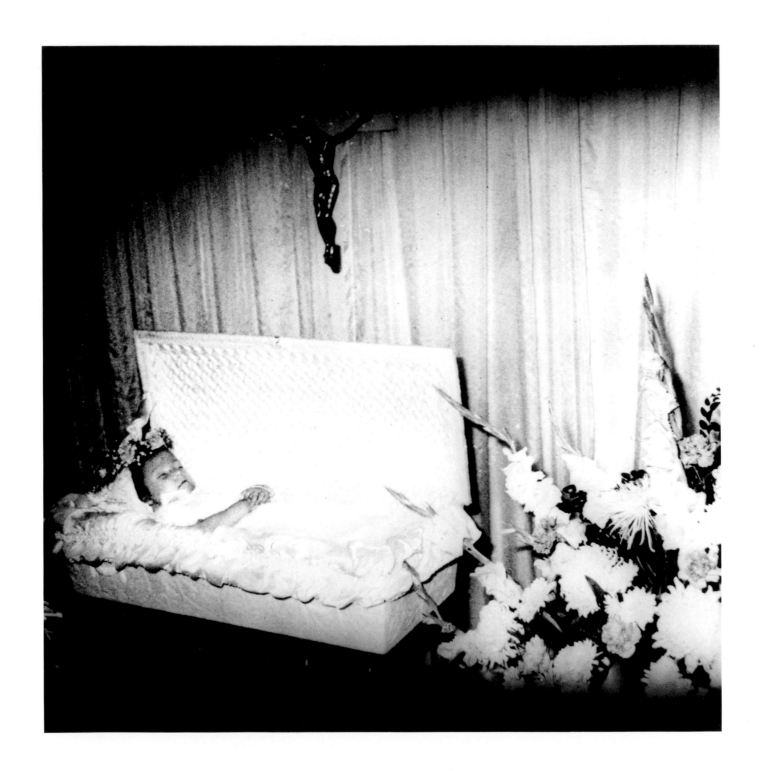

FLAVIA'S FUNERAL, Brooklyn, NY, 1985

WOMEN RECITING ROSARIES AT FLAVIA'S FUNERAL, Brooklyn, NY, 1985

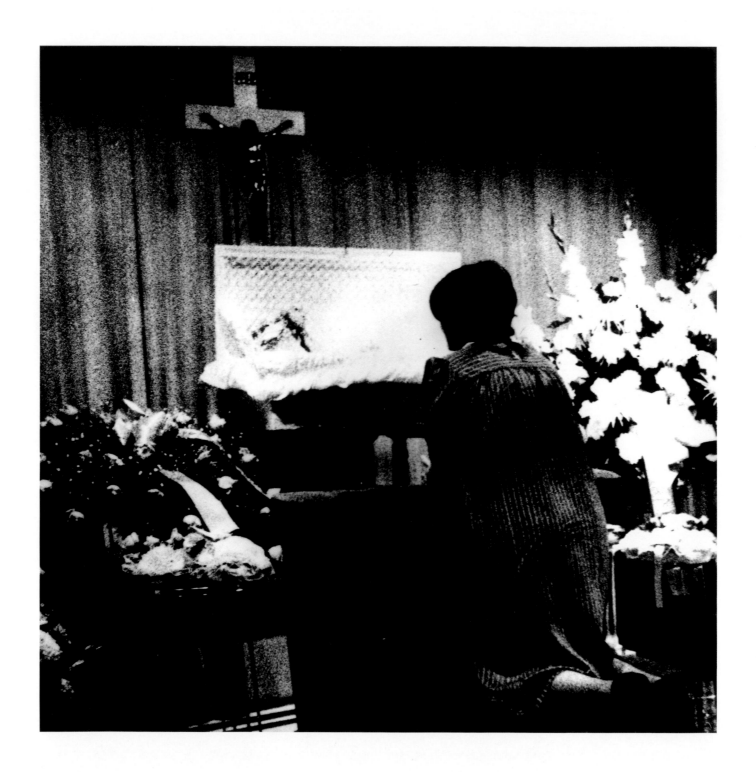

MARIA AT FLAVIA'S FUNERAL, Brooklyn, NY, 1985

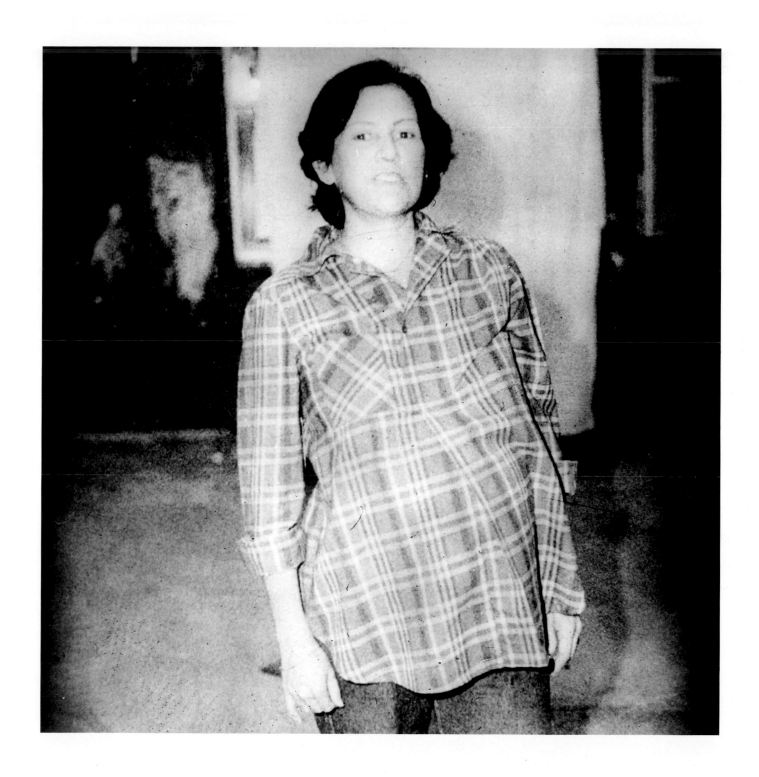

MARIA, EIGHT MONTHS PREGNANT WITH ADRIANA, Brooklyn, New York, 1985

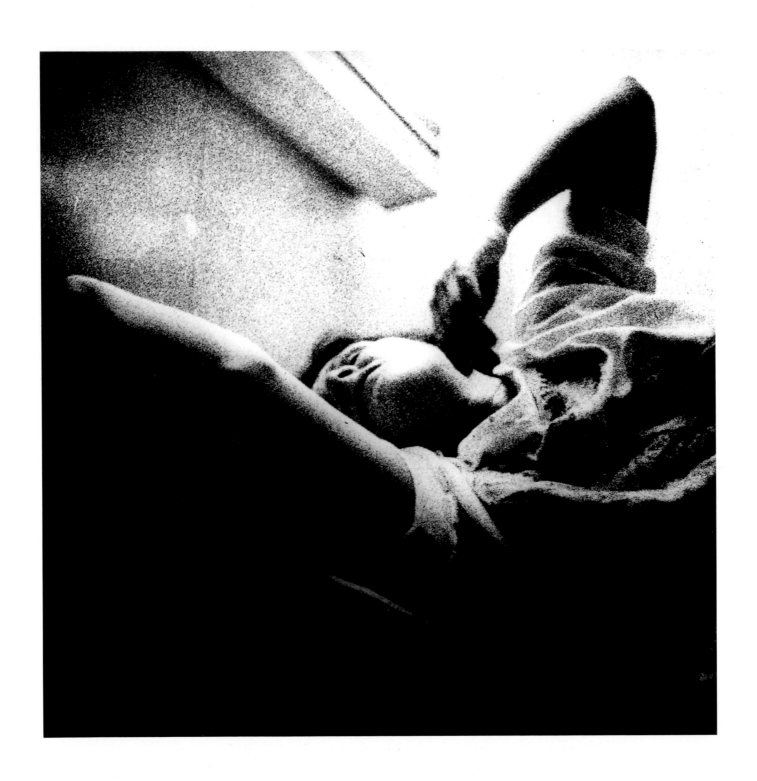

MARIA IN LABOR WITH ADRIANA, Brooklyn, NY, 1986

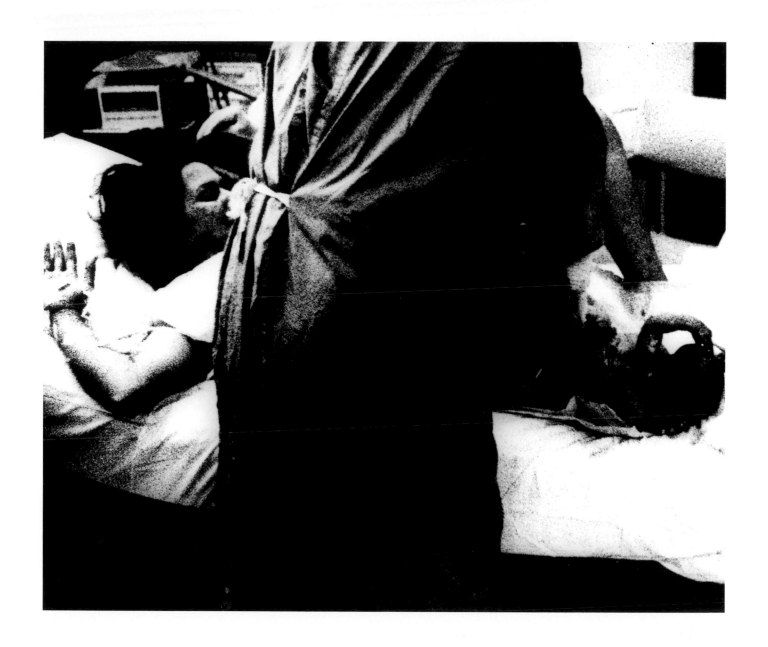

MARIA IN LABOR WITH ADRIANA, Brooklyn, NY, 1986

tious," and to cover themselves with masks and gowns when entering her room, even though her form of pneumonia was not contagious.

At this point, Flavia's condition was getting worse, and she was placed in intensive care in a different wing of the hospital. It was then, realizing that her first child was going to die, that Maria asked me to take a picture of Flavia. This was the first photograph I made for the AIDS project.

Meanwhile, Fernando was hospitalized in Brazil. He and Maria tried to comfort each other over the phone as their child was dying, knowing that they would probably never see each other again. Three months after Flavia's death, Adriana was born; a month later, Fernando died. While Maria was in labor, the attending physician, who knew she had AIDS, demanded of her: "Why are you having this baby? You're going to die soon. Your baby is going to die, and I could get infected."

It takes nine to fifteen months for a baby to shed the mother's antibodies. Only then can a test reveal if the baby is HIV positive. Month by month we watched Adriana grow, never knowing whether or not she was infected. In the thirteenth month, she tested negative. Adriana's consistent good health, AZT, and a drug to prevent the pneumonia from recurring kept Maria strong for the next year.

During the following three and a half years, however, Maria's health declined progressively as the AIDS virus continued to destroy her immune

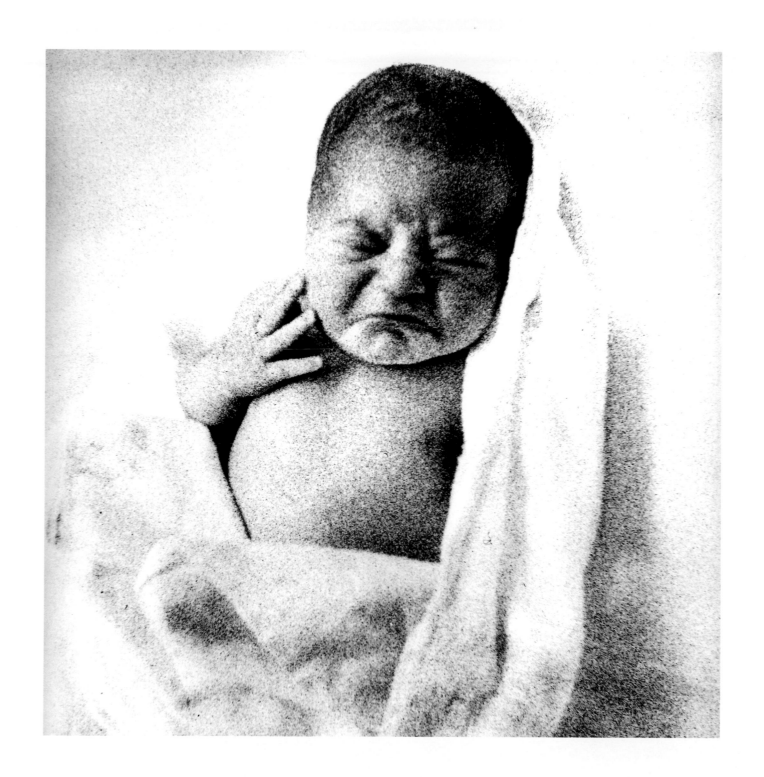

ADRIANA, TWENTY MINUTES OLD, Brooklyn, NY, 1986

MARIA AND ADRIANA VISITING THE FAMILY GRAVE, Brooklyn, NY, 1986

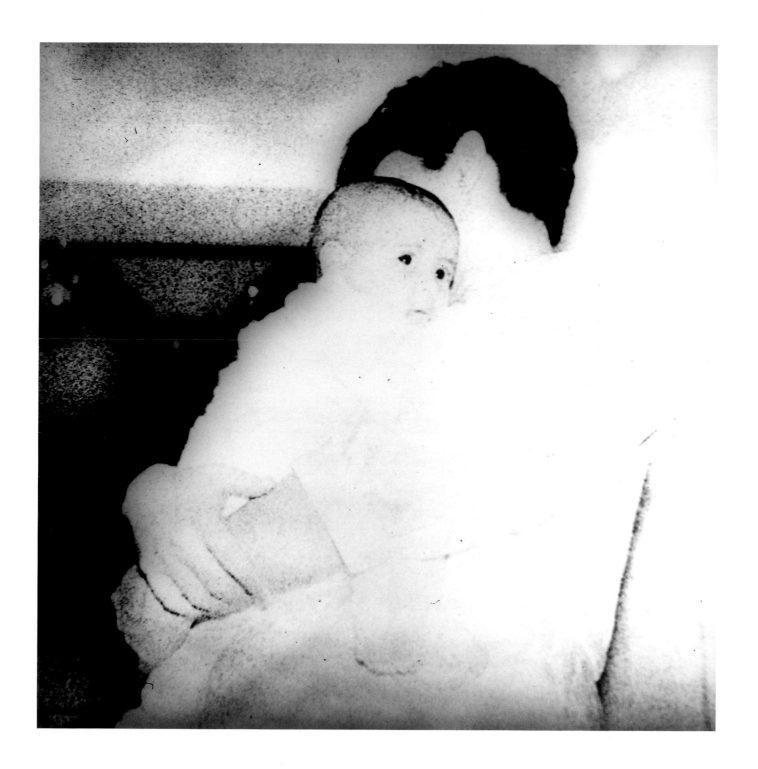

MARIA AND ADRIANA ON CHRISTMAS MORNING, Brooklyn, NY, 1986

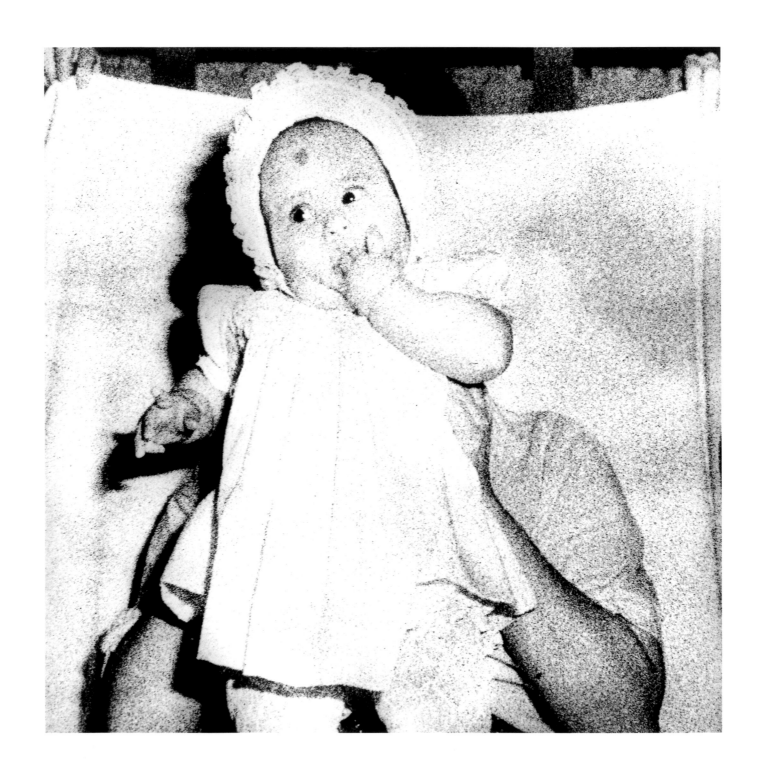

ADRIANA'S FIRST BIRTHDAY, Brooklyn, NY, 1987

MARIA AND ADRIANA AT TWO, Brooklyn, NY, 1988

ADRIANA'S THIRD BIRTHDAY, Brooklyn, NY, 1989

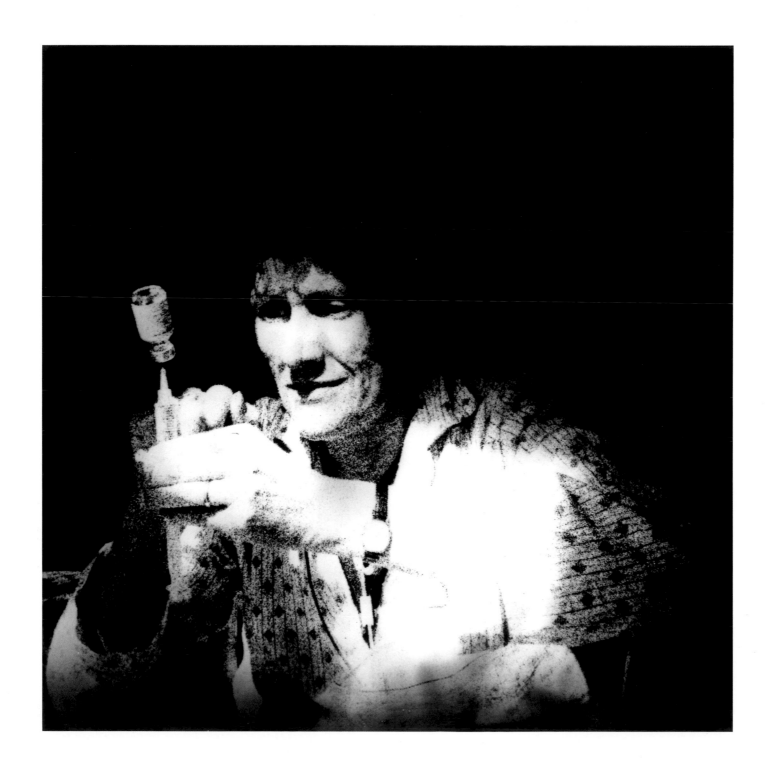

MARIA, SELF-INJECTING EXPERIMENTAL DRUG, Brooklyn, NY, 1990

system. She struggled with meningitis, lost her vision in one eye, and was going blind in the other. She had daily transfusions that lasted between four and six hours. She was eventually unable to keep food down, and lost twenty pounds. Regardless of her physical condition, Maria always struggled to maintain a loving and stable home for Adriana.

After meeting Maria, I had made myself believe that together, no matter how frightening or difficult things were, we'd get through. But in the summer of 1991, it seemed that it was time to prepare for the end. Having already endured the pain of losing her husband and two-year-old daughter, Maria was now faced with saying good-bye to Adriana. She knew she was reaching the final stages of her illness and soon would not have the strength left to take care of her. From her hospital bed at Memorial Sloan-Kettering, Maria held Adriana and kissed her good-bye. Adriana was then sent to Puerto Rico to live with her relatives.

With no strength left to fight, and only sadness to fill the silence created by Adriana's absence, Maria's confusion and dementia increased rapidly. Within three weeks she had slipped out of reality and into the past. She lost her sense of time, eventually even forgetting she had ever been ill. When she finally went blind, she was too confused to notice. On August 29, at 7:30 A.M., Maria died. She was thirty-eight years old.

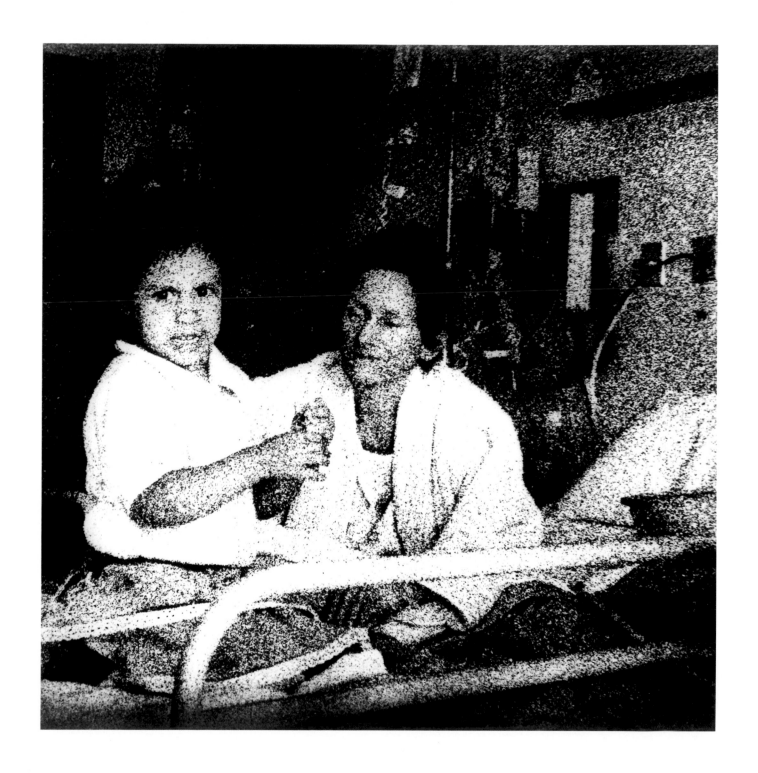

MARIA AND ADRIANA SAYING GOOD-BYE, Memorial Sloan-Kettering Hospital, New York City, 1991

ACT UP (AIDS Coalition To Unleash Power) is a diverse non-partisan group united in anger and committed to direct action to end the AIDS crisis. We meet with government and health officials; we research and distribute the latest medical information. We protest and demonstrate. We are not silent. Right now, as you read this, ACT UP is: confronting politicians at rallies, debates, and conventions to demand that they clearly articulate a plan to end the AIDS crisis; confronting public health officials about the devastating impact of the tuberculosis epidemic on people living with AIDS; aggressively leading the charge against Blue Cross rate increases and advocating for statewide insurance reform; handing out condoms to students in front of junior and senior high schools throughout the city; and actively working with the International AIDS Conference to expand its agenda to include alternative, complementary, indigenous, and traditional medicine. Silence = death. Action = life.

—excerpted from an ACT UP/NY informational statement, 1992

In 1990 ACT UP members rallied at the National Institutes of Health in Bethesda, Maryland, demanding that new drugs for people with AIDS get released more quickly, and insisting that more research be done regarding women with HIV. People came from all parts of the country for the demonstration that morning. They were met by a small army of police in full riot

ACT UP

gear, some wearing rubber gloves as a precaution in the event of bloodshed. As the rally progressed, there was violence: whenever the police felt that the demonstrators were getting out of hand, they would move into the mass, clubbing people with their sticks and dragging protestors off to waiting vans. ACT UP/Chicago formed a circle and bound themselves together with gaffer's tape. After a brief stare-down, the cops, some of whom were on horseback, charged into them. The protestors were clubbed and trampled on, but they were so tightly taped together that the police were unable to arrest them.

By the end of the day, over fifty people were in jail and many others had gone home with serious injuries. The national news devoted four seconds of film coverage to the event that night, and the following day *The New York Times* only acknowledged it with a three-inch column.

ACT UP is steadfast in its mission to work for the end of the AIDS epidemic. They are not about to be silenced, and they cannot be ignored.

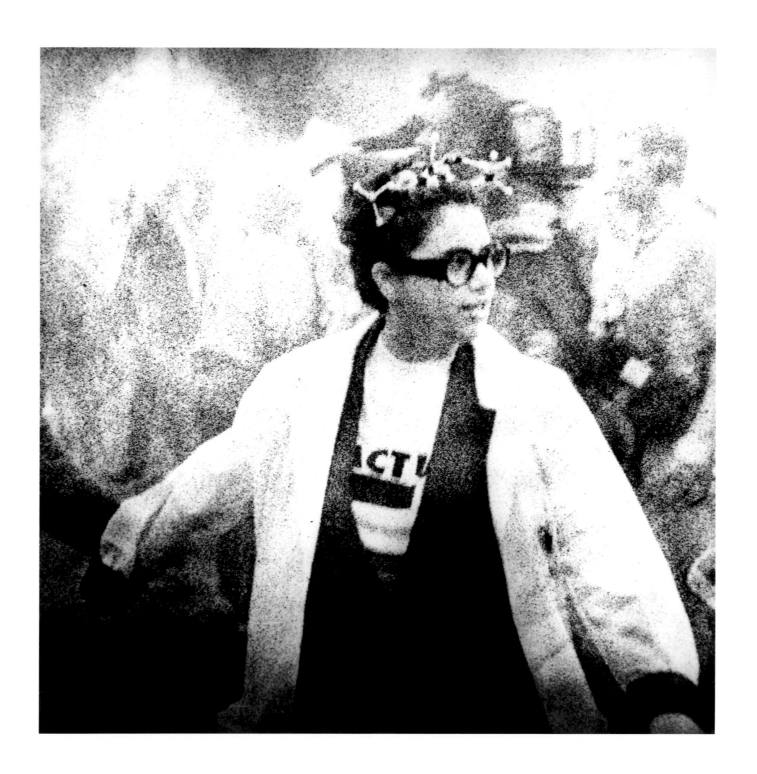

ACT UP DEMONSTRATION, NATIONAL INSTITUTES OF HEALTH, Bethesda, MD, 1990

ACT UP DEMONSTRATION, CITY HALL, New York City, 1988

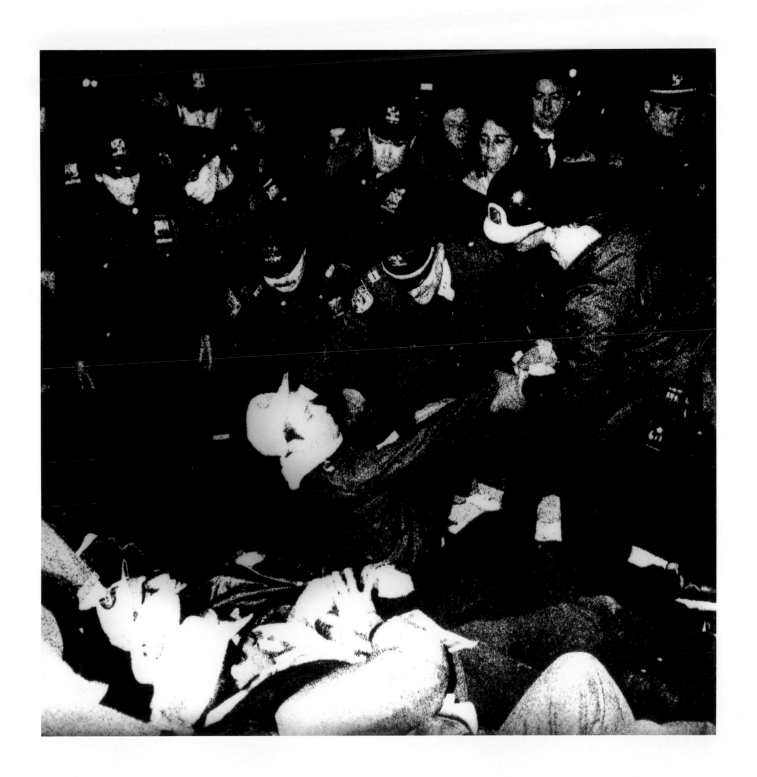

ACT UP "DAY OF DESPERATION," 42nd Street and Lexington Avenue, New York City, 1991

Pictures of children with AIDS are very tricky in that they often appear with the "innocent victim" tag—the implication being that other people with AIDS are somehow guilty. Sympathy for one group over any other group is offensive to everyone concerned.

Beginning in 1986, I was a volunteer at a large, metropolitan hospital. For a couple of years I cared for two boys with AIDS, Nicky and Giovanni.

When Nicky was five and a half years old, he entered the hospital. No one knew how he had contracted the virus. He could have been positive since birth and asymptomatic until he was five years old. He could have been molested, or stuck himself with an infected needle. Nicky was a street-smart kid when he came into the hospital. He had an infection in his throat and swollen glands. Six months later, he had lost over a third of his body weight. His legs were like sticks and his stomach was distended. His diarrhea was so uncontrollable that he had to wear a diaper. He always wondered why the other kids got better and went home, and he didn't.

Over the next year and a half, I watched Nicky waste away. He became

CHILDREN

sore just from lying in bed, and loved floating in the bathtub—it was the only time his body felt free. Nicky was the only child in the ward with his own room and he liked that—I think he felt that it was the only thing in his life he could somehow control. As Nicky's seventh birthday approached, we decided to have a party for him. We called his father, who promised he would be there. The afternoon of the party, Nicky sat in his room all dressed, refusing to move until his father came. After an hour we realized that his father wasn't going to come, so we took him to the party alone. We practically had to force him to open his presents.

Two days later, we found out that, on his way home after cashing a paycheck, Nicky's father had been murdered. The police had found him lying in the park, and three hours later he'd died in the hospital of a bullet wound to the stomach. Nicky had to be told. We all knew he couldn't hang on much longer, but he couldn't spend the last weeks or months of his life waiting in vain for his father to visit. The news took away all the fight that was left in him.

One evening, I sat in the intensive-care unit holding his hand in the dark. He was fading in and out. He squeezed my hand, turned to me and said, "Are you tired? You must have had a long day. I'm pretty tired myself." Nicky closed his eyes and fell asleep. He died later that night.

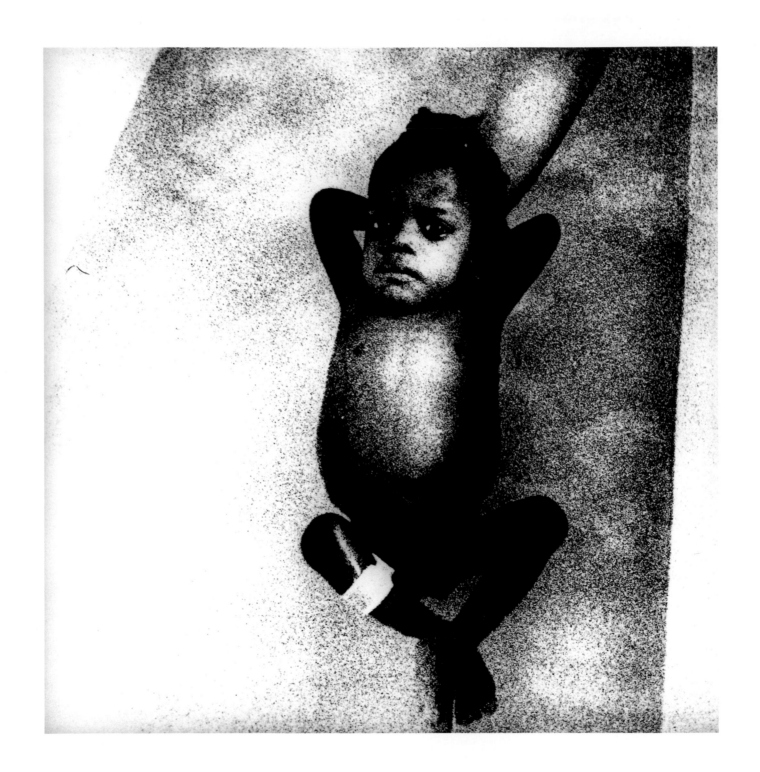

PRINCE, TWO-YEAR-OLD WITH AIDS, New York City, 1986

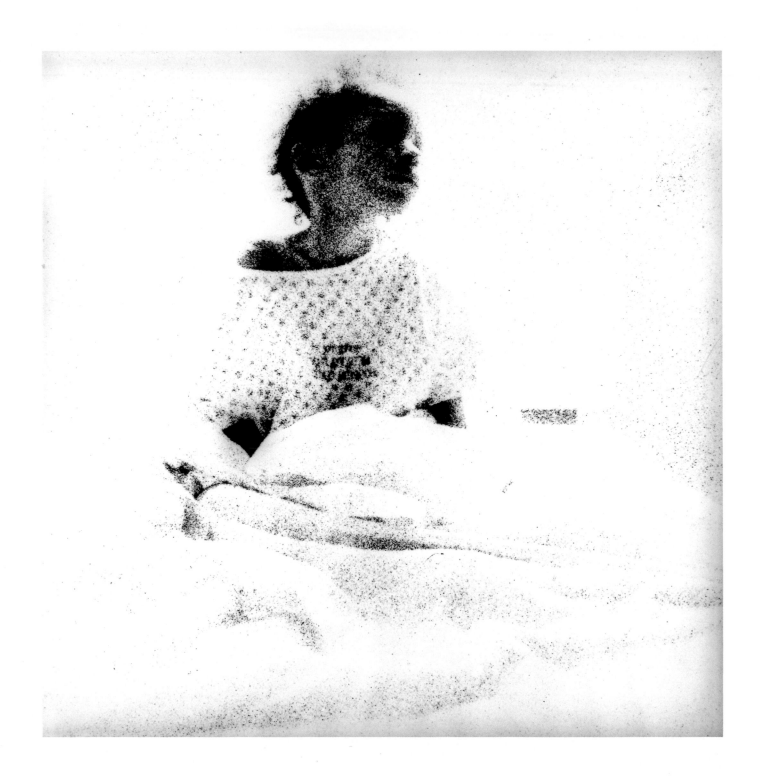

GIOVANNI, SEVEN-YEAR-OLD WITH AIDS, New York City, 1986

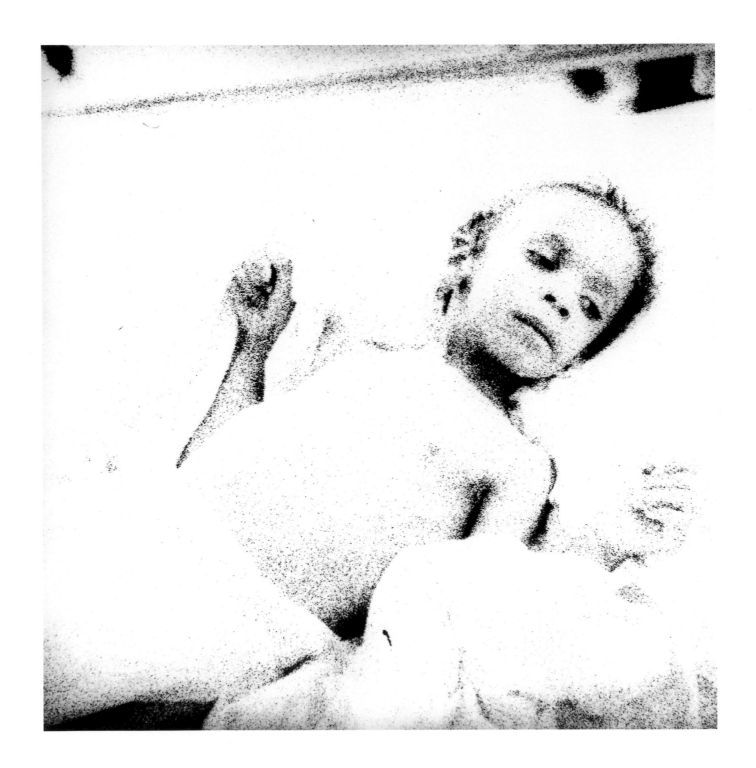

GIOVANNI, SEVEN-YEAR-OLD WITH AIDS, New York City, 1987

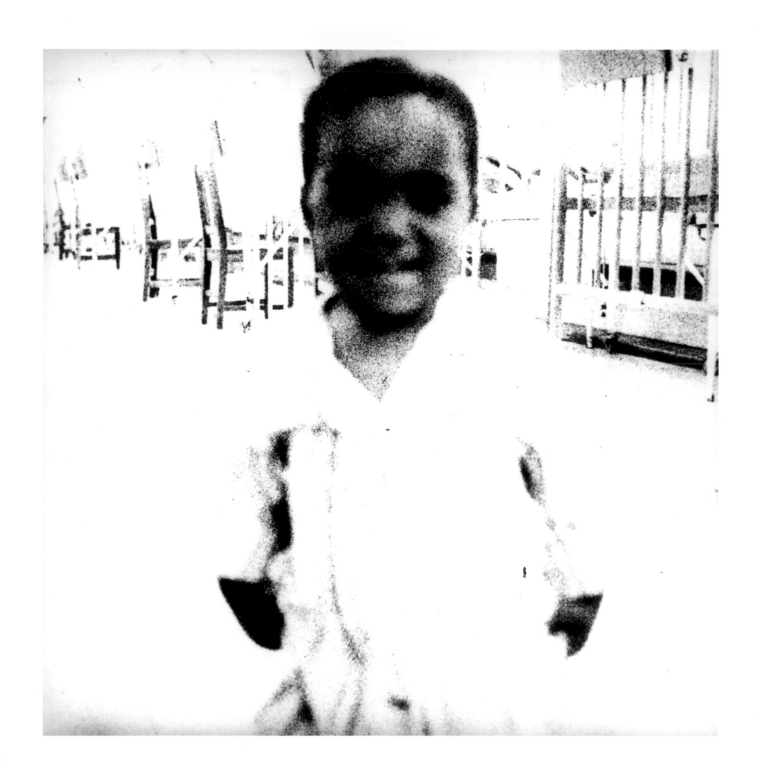

CHILD WITH AIDS IN ALEXANDRA TOWNSHIP, Johannesburg, South Africa, 1990

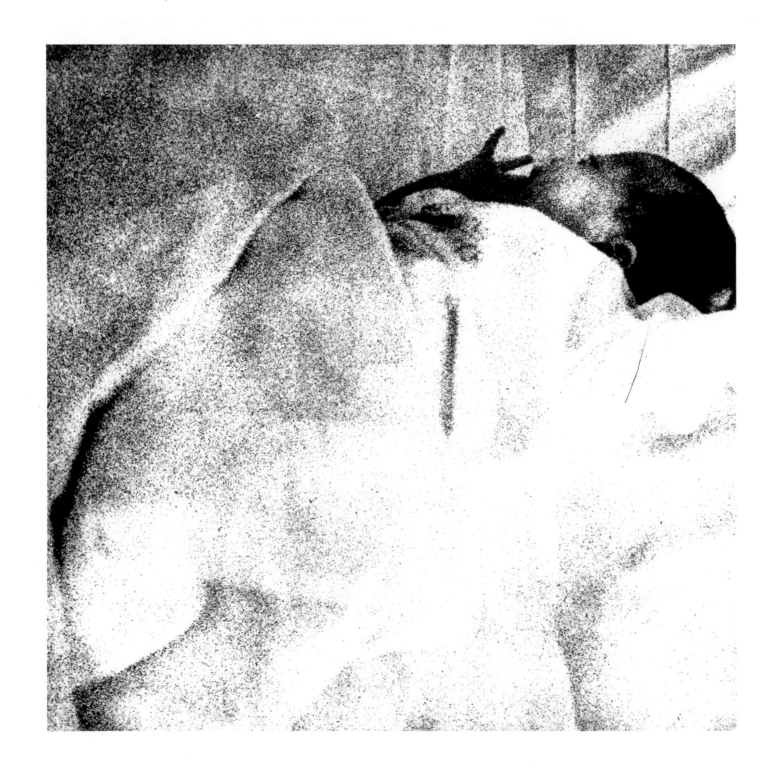

ANGELICA, NEWBORN WITH AIDS, Bronx, NY, 1986

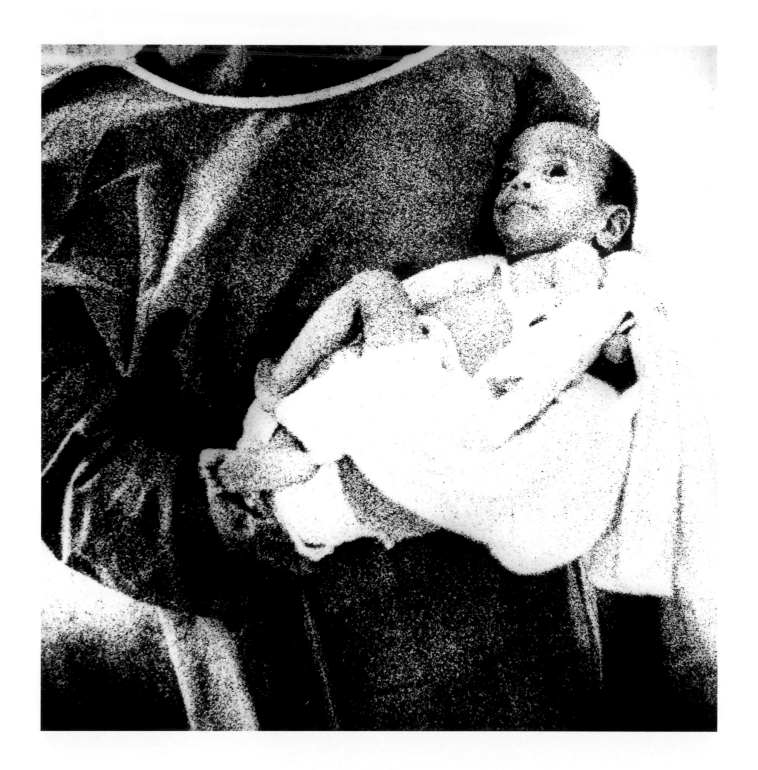

ANGELICA AT ONE AND A HALF, Bronx, NY, 1987

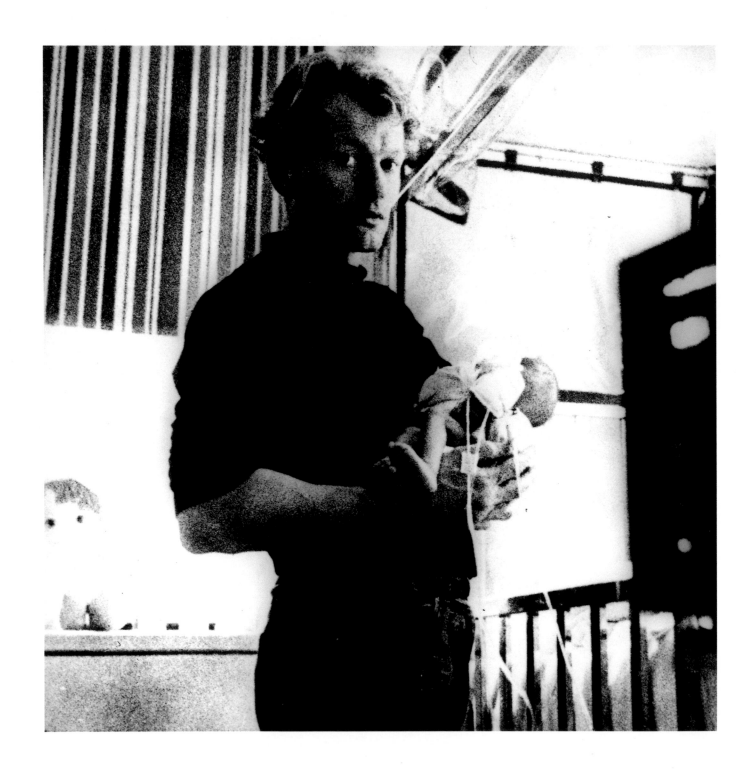

ANGELICA AT TWO AND A HALF, Bronx, NY, 1988

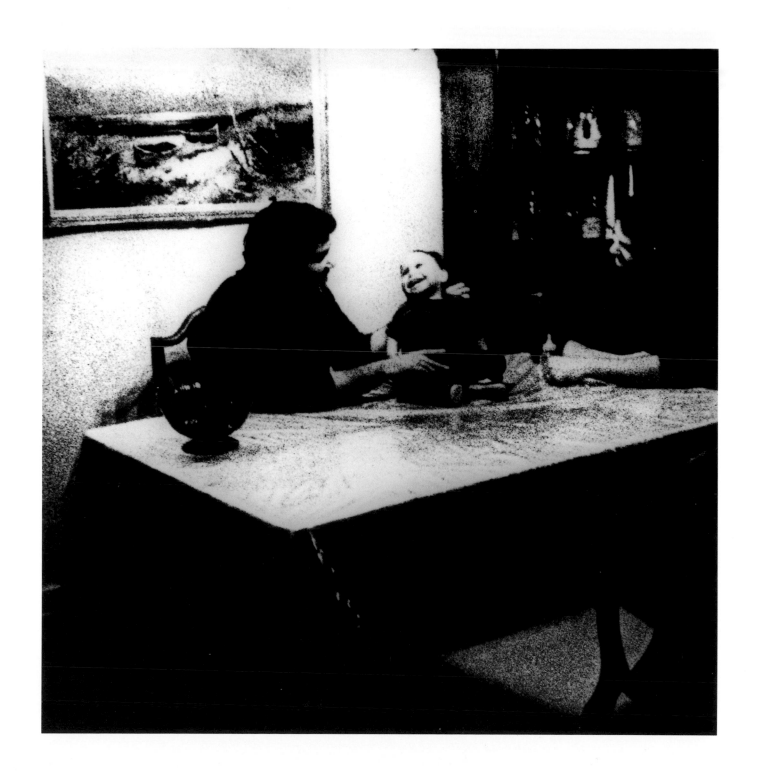

GAY FOSTER PARENTS DON AND FRANK WITH THEIR TWO-YEAR-OLD SON WITH AIDS. DON AND FRANK ARE PARTICIPANTS IN A PROGRAM, ESTABLISHED THROUGH THE LEAKE AND WATTS ADOPTION AGENCY, WHICH PLACES CHILDREN WITH AIDS IN FOSTER HOMES. Queens, NY, 1987

It was three in the afternoon at the Waldorf Hotel. Alfred and I wore summer linen suits with ties as we sipped our tea and ate finger sandwiches and scones with jam. The room was filled with older women also having high tea. Some were accompanied by their young grandchildren who sat impatiently, wearing their best clothes and sipping Cokes. The kids couldn't stop staring at Alfred, and it seemed to make their grandmothers noticeably uncomfortable.

One morning in the shower, four years before, Alfred had found a small purple spot on his leg. Now, his whole body and most of his face was covered with purple lesions from Kaposi's sarcoma. Two years before, an ophthalmologist had diagnosed him with a virus that affects the retina of the eye. It was now obvious (even to the child at the next table), by the way Alfred moved his cup to his mouth, that he was almost blind. Unaware

ALFRED

of the surrounding stares, Alfred spoke about the seasonal directions of the trade winds and their importance to the spread of Islamic culture from the Middle East to eastern Africa. Alfred was thirty years old, and inside his deteriorating body was trapped one of the most intelligent and inquisitive minds I have ever known. Alfred had been named after his grandfather, Alfred H. Sturtevant, the renowned geneticist, who worked with Thomas Hunt Morgan, Calvin B. Bridges, and Hermann J. Muller, researching the genetic trends in generations of the *Drosophila* fruit fly. Their discoveries won them the Nobel prize in 1946. Alfred's maternal grandfather had been the last colonial king of Burma. Alfred grew up in Washington, D.C., where his father had worked as curator at the Smithsonian.

At twenty-three, after graduating from Yale, Alfred moved to New York City and worked as an editor and art critic. He was tall and thin with striking Eurasian features. He met another young man, a painter, and for years they had a passionate love affair. They ended the relationship, only to come back together years later to support one another as each approached his own imminent death from AIDS.

Entering Alfred's apartment, one walked through pathways defined by stacks of books and magazines. In his bedroom was a small shrine and a figure of Buddha. When taking care of Alfred, his mother would sit in front of the Buddha for hours and say her prayers. When she first found out that Alfred was sick, she asked a famous monk in Burma to make a jar of sacred honey for Alfred's health and healing. It had taken over a year for the monk to collect and bless the honey. Alfred kept it in a plastic honey-bear on his kitchen table.

Two weeks after our tea at the Waldorf, Alfred entered the hospital for the last time. His Kaposi's sarcoma was causing bleeding ulcers in his lungs. He had also developed pneumonia. His doctors were having difficulty treating a rare form of disseminated tuberculosis that Alfred had recently contracted. Over the next few days, a series of complications developed, and Alfred's sister realized that it was time to tell the rest of the family to come to New York as quickly as possible. The following day, a meeting was held with his family. The doctors explained that soon Alfred's lungs would not be able to oxygenate his blood, which could lead to heart failure. It was their opinion that it would be best not to intervene but to let him die. However, Alfred's signature on a "do not resuscitate" form would be the only way to stop the doctors' intervention. The family was now presented with the task of explaining this to Alfred.

The last time I saw Alfred he was lying on a gurney waiting to be moved to intensive care. He handed me one of the earplugs from his Walkman so together we could listen to an opera he had always loved. I remember holding his hand and as we listened, he translated the story from Italian into English. This beautiful young man, with an incredible and lucid mind, was about to die. Two hours before translating this opera for me, Alfred had signed his own "do not resuscitate" form. Twenty-four hours later he was dead.

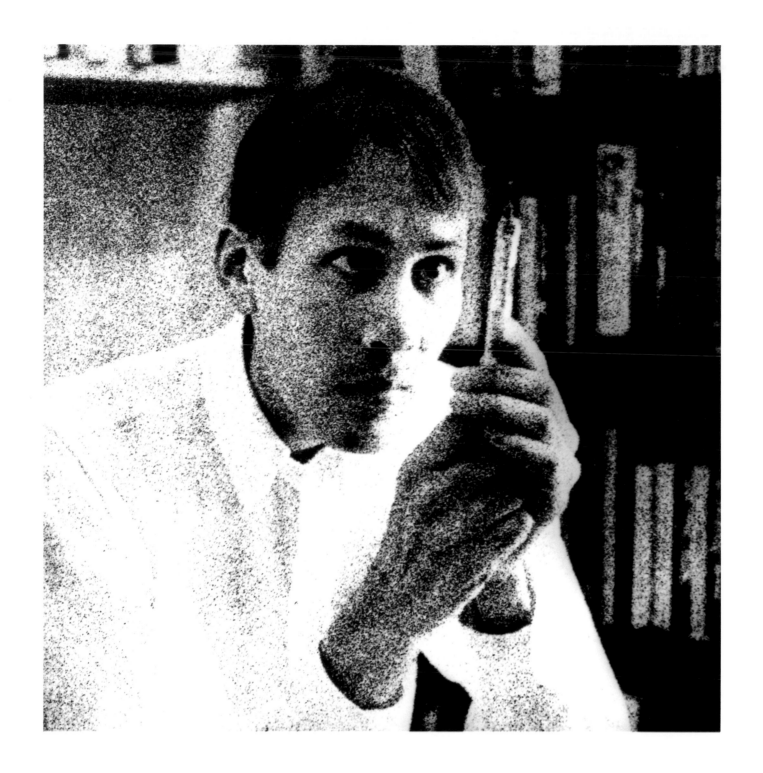

ALFRED, SELF-INJECTING EXPERIMENTAL DRUG, New York City, 1987

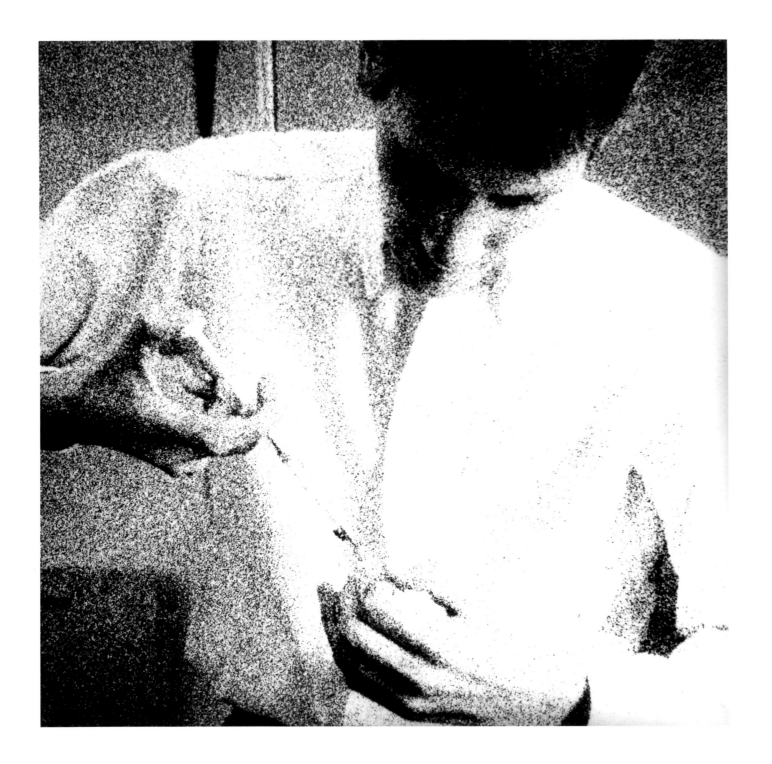

ALFRED, SELF-INJECTING EXPERIMENTAL DRUG, New York City, 1987

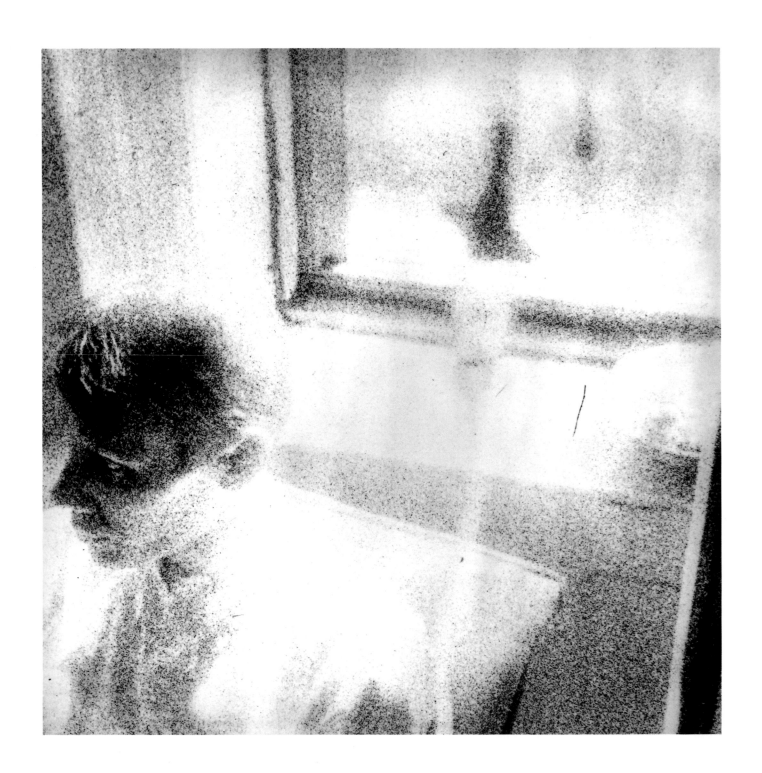

ALFRED, New York City, 1988

David was born in Newark, New Jersey. He had been injecting heroin since the age of fourteen. At thirty-six he was homeless, and had recently finished a four-year sentence for armed robbery. He began injecting heroin again as soon as he hit the streets. As his drug habit increased, he began to lose weight. He assumed that his diarrhea and nausea were results of the impure quality of the heroin he was taking. But David's need for drugs and his subsequent desperation for money to pay for the heroin left him little time to worry about his health.

One day, unable to control his bowels any longer, now weighing 125 pounds, David ended up in the emergency room of Bellevue Hospital. He

lay on a gurney in a hall for two days before a bed became available. On the third day, sweating and convulsing in the midst of withdrawal from the drug, he finally saw a doctor, who told David that various blood tests had come back, and that he was HIV positive. It was 1985 in New York and David had never heard of AIDS. He had been injecting drugs for seventeen years, wherever and whenever he could, and yet he had no idea how AIDS was spread, no idea that sharing needles could be a means to contract the disease. David was moved into a room on the AIDS ward with seven other patients. Within the next two days, three of the men in the ward died.

David remained at Bellevue, and neither his family nor his friends visited him there. After three months, his condition stabilized, and he was released. Unable to deal emotionally with the knowledge of his illness, and finding little support and few available services, David returned to the streets. Three weeks later, he was found dead in a shelter in Brooklyn.

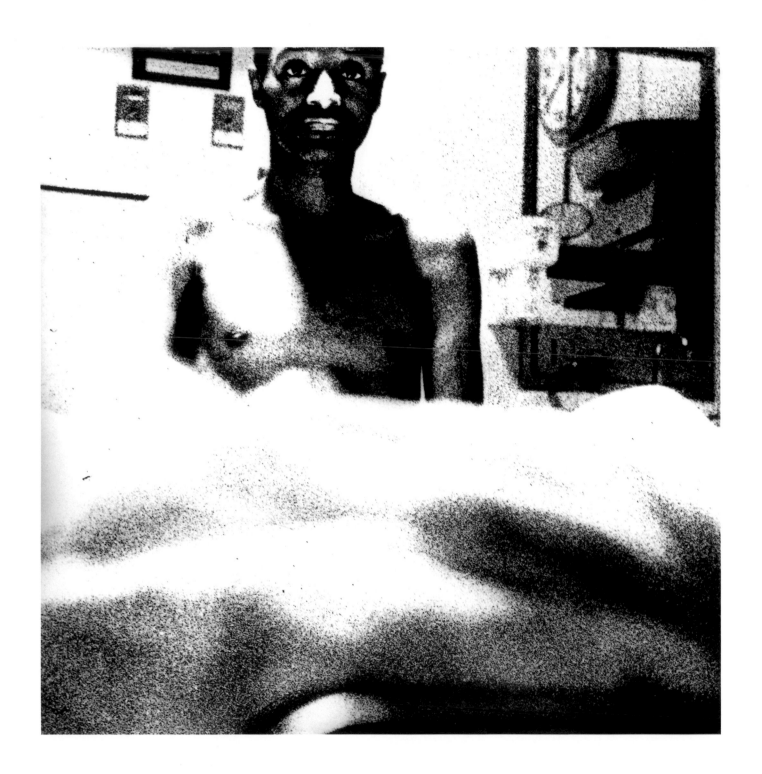

DAVID AT BELLEVUE HOSPITAL, New York City, 1988

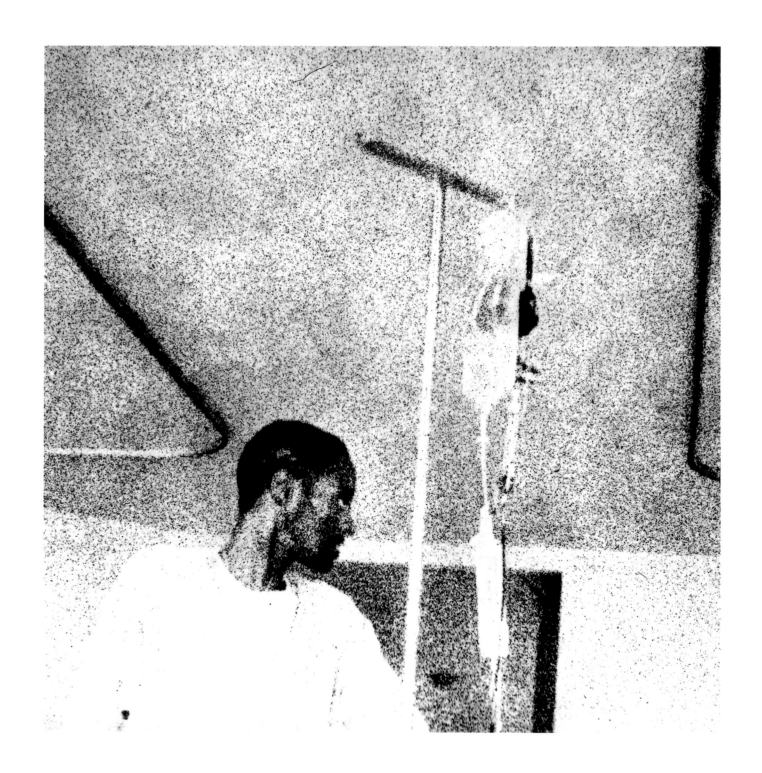

DAVID AT BELLEVUE HOSPITAL, New York City, 1988

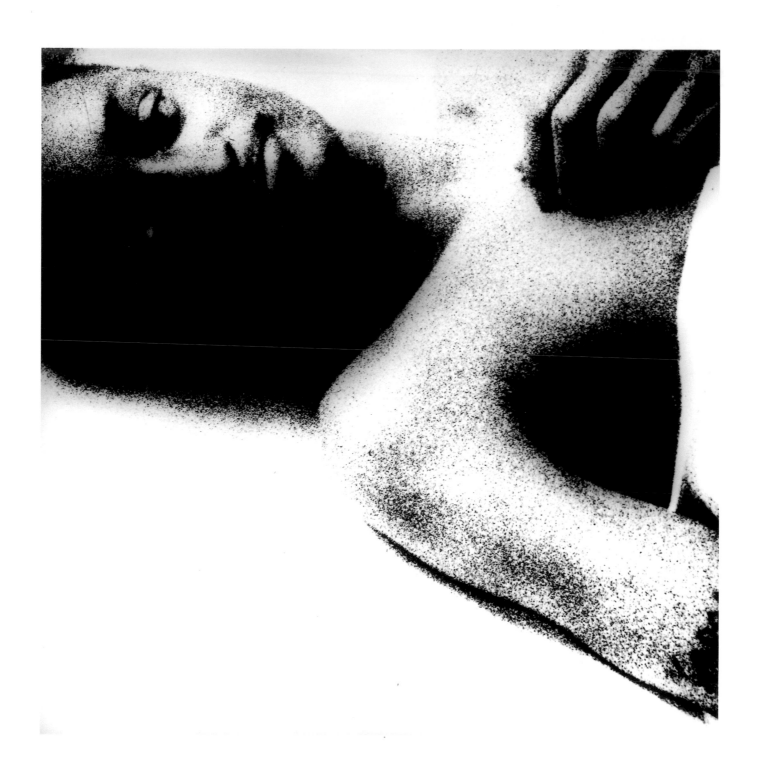

DAVID AT BELLEVUE HOSPITAL, New York City, 1988

In the United States the quality and availability of medical services are, in the end, dictated by one's economic means. The poorer people living in inner-city areas such as the Bronx, Newark, Oakland, New Haven, or Detroit generally have medical services comparable to those available in the Third World.

Currently, intravenous-drug users and their sexual partners make up more than 50 percent of the population of people with AIDS in New York City. While the gay community has been able to curb the spread of HIV through education, the number of infected among the IV-drug-using population continues to grow. There are an estimated 250,000 IV-drug users in New York.

NEEDLE EXCHANGE

Conservative estimates from the Department of Health indicate that at least 60 percent of that population is HIV positive. Although it is seldom reported in the media, AIDS has become a predominantly heterosexual disease in many inner-city communities in the United States and abroad. Several of these photographs were taken in Liverpool, England, where a highly successful needle-exchange program has been functioning for years. Addicts are given clean needles in exchange for their used ones in a government-funded distribution program. Liverpool has had a very large population of drug addicts since the '60s, but due to this free distribution of needles there have only been three or four reported cases of AIDS in the whole city among IV-drug users.

Other photographs were taken in a "shooting gallery" in Chicago. Over the course of an afternoon there, thirty people came to rent (and share) needles. One man in the Chicago series is a diabetic, with a prescription for syringes; that was how he paid for his drug habit. He got two or three syringes every week and rented them out to hundreds of people. The day I

was there, they were sharpening a needle on matchbook flints because it was too dull to inject with.

The Liverpool clean-needle-exchange program is run on a budget of $75,000 a year. Caring for one person with AIDS in a city hospital will cost New York City between $60,000 and $150,000 during the course of the illness.

Needle exchange has been clearly demonstrated as the most effective means of curtailing the spread of AIDS among IV-drug users. While New York City has the largest number of IV-drug users in the United States, possession or distribution of needles was, until June 1992, prohibited by law. Undermined by financial cutbacks, the already overburdened drug-treatment programs cannot begin to meet the needs of an estimated 250,000 IV-drug addicts and 400,000 crack addicts. Without available or effective treatment, needle exchange is the only means of holding back the spread of the virus among what has now become the largest population of people with AIDS in New York City.

In 1989, an alliance was formed between ACT UP/New York and the AIDS Brigade in Boston, in order to develop needle-exchange programs in both cities. Teams were formed to cover different high-drug-use neighborhoods in these cities. I worked with the program, first in the South Bronx and later in Harlem. Although there were fewer than twenty of us working in New York when the Dinkins administration began its program, we were already distributing 4,000 needles throughout the city every Saturday. We were also giving out condoms, bleach to clean dirty needles, as well as information about treatment. As an estimated 60 percent of the people who receive clean needles are HIV positive, the need to act as a link between them and some form of effective medical and drug-treatment service is extremely urgent.

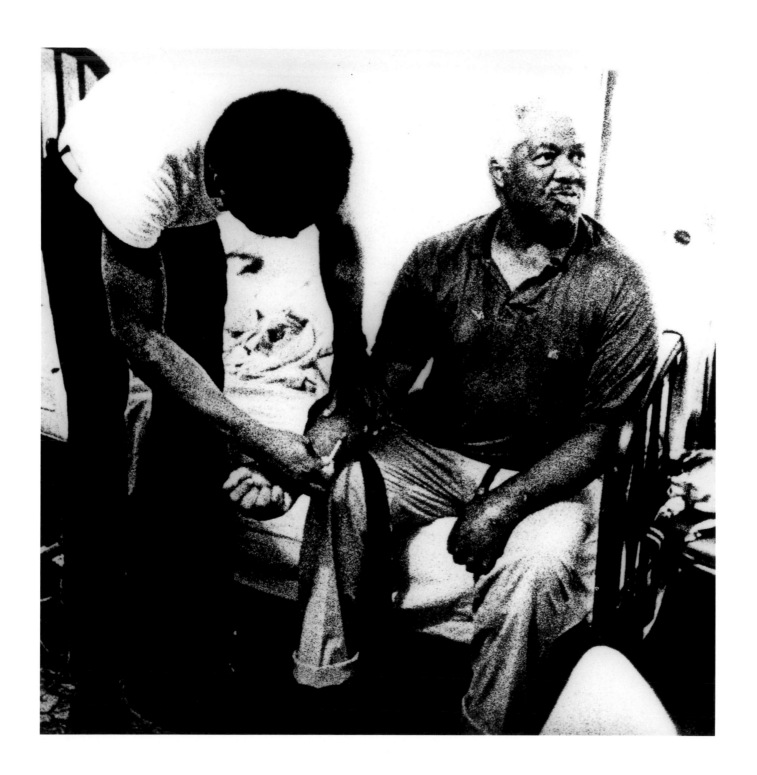

MEN SHARING A RENTED NEEDLE AT A SHOOTING GALLERY, Chicago, IL, 1986

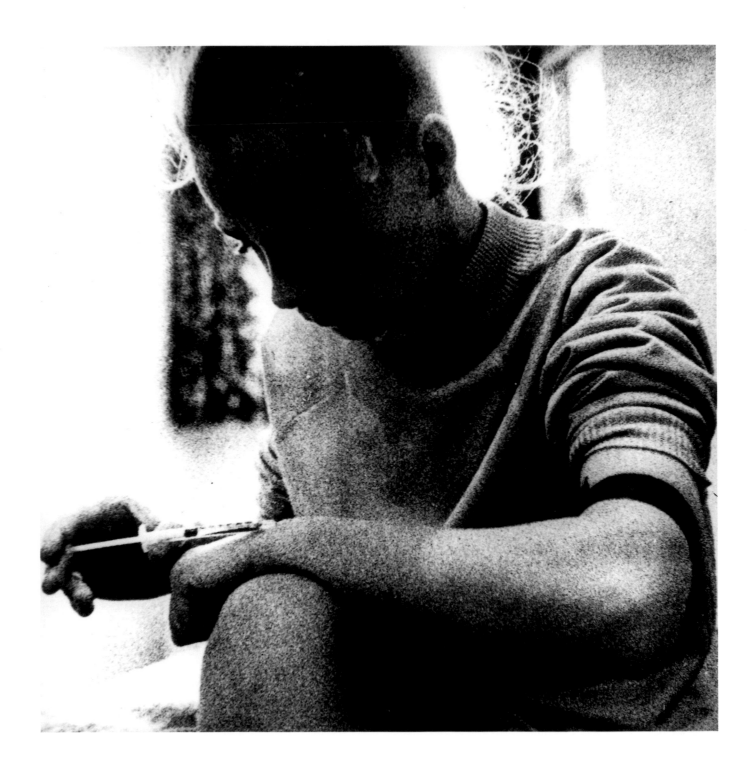

WOMAN USING A CLEAN NEEDLE PROVIDED BY LIVERPOOL NEEDLE-EXCHANGE PROGRAM, Liverpool, England, 1988

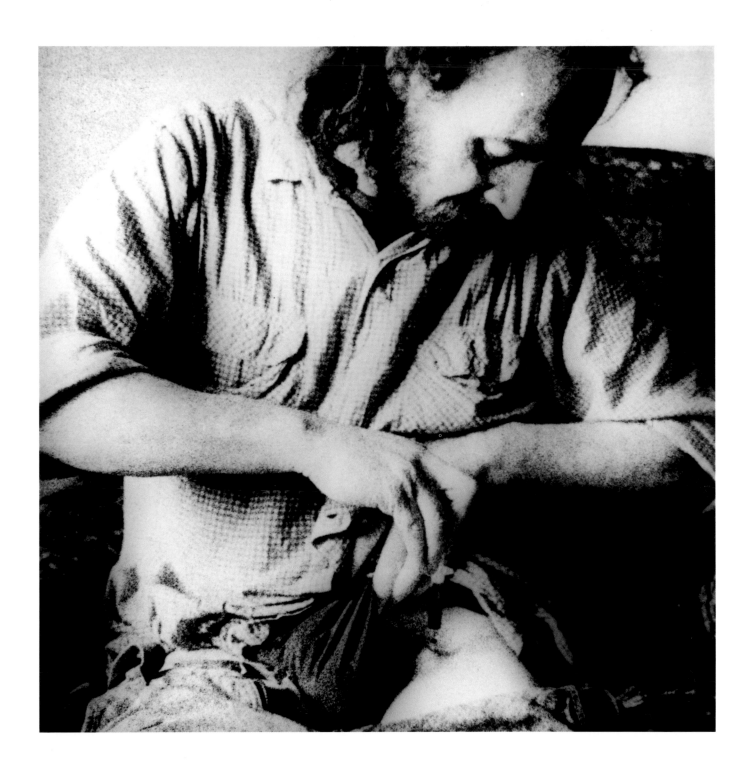

MAN USING A CLEAN NEEDLE PROVIDED BY LIVERPOOL NEEDLE-EXCHANGE PROGRAM, Liverpool, England, 1988

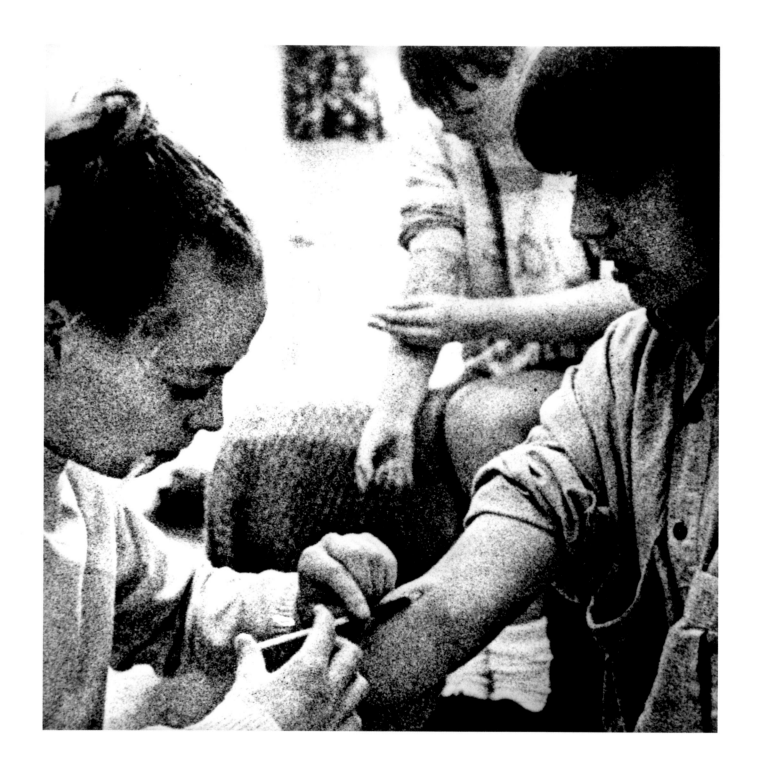

YOUNG SEX WORKERS INJECTING DRUGS, Liverpool, England, 1988

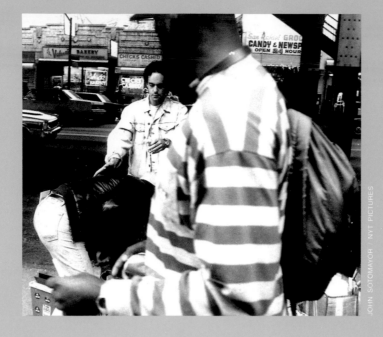

BRIAN WEIL (BACKGROUND) DISTRIBUTING CLEAN NEEDLES, 1991

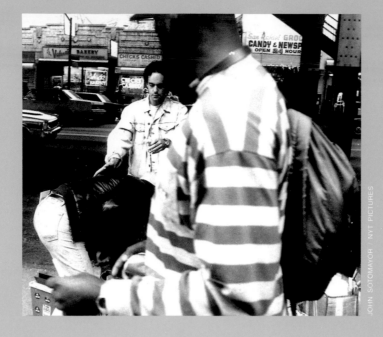

SAFE SEX

Safe sex is not about denying or inhibiting your sexuality; nor is it necessarily about abstention. It's just about not infecting yourself and others. These images were made to educate people about safe sex, and to eroticize it. Two of them, made on the set of a porn movie, demonstrate how condoms can be erotically integrated into sexual activity between men. Prophylactics are not always immediately accepted into sexual practice. In fact, for both male and female sex workers—the term used by health-care workers when referring to someone who sells sex for money—protected sex often means fighting cultural resistance to the use of condoms. Therefore, a method was devised for the sex worker first to hide a condom in his or her mouth, and then, secretly, to slip it onto the penis of the client. Safe-sex outreach workers use dildos to demonstrate and teach this technique.

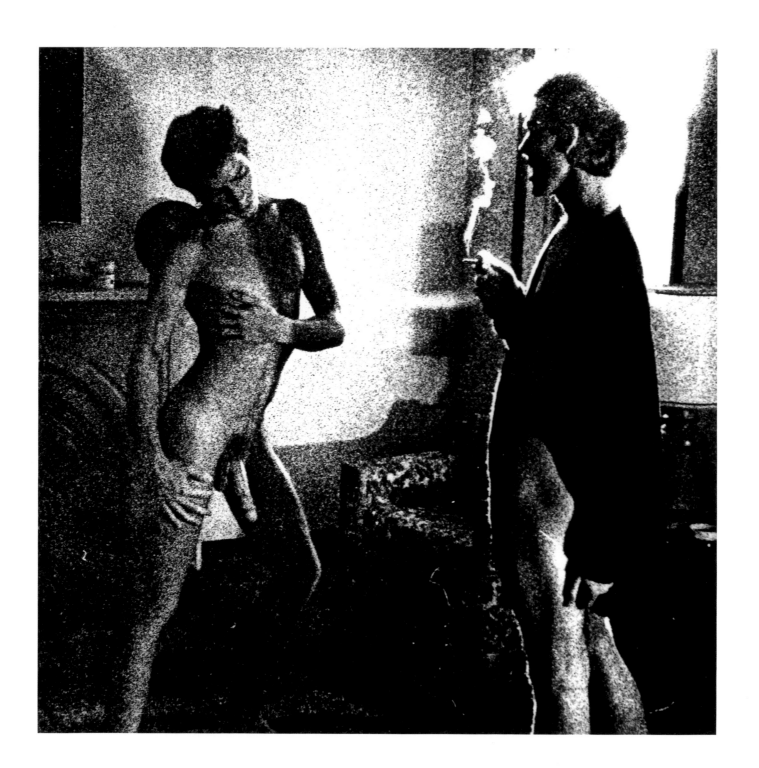

SAFE SEX, Chicago, IL, 1987

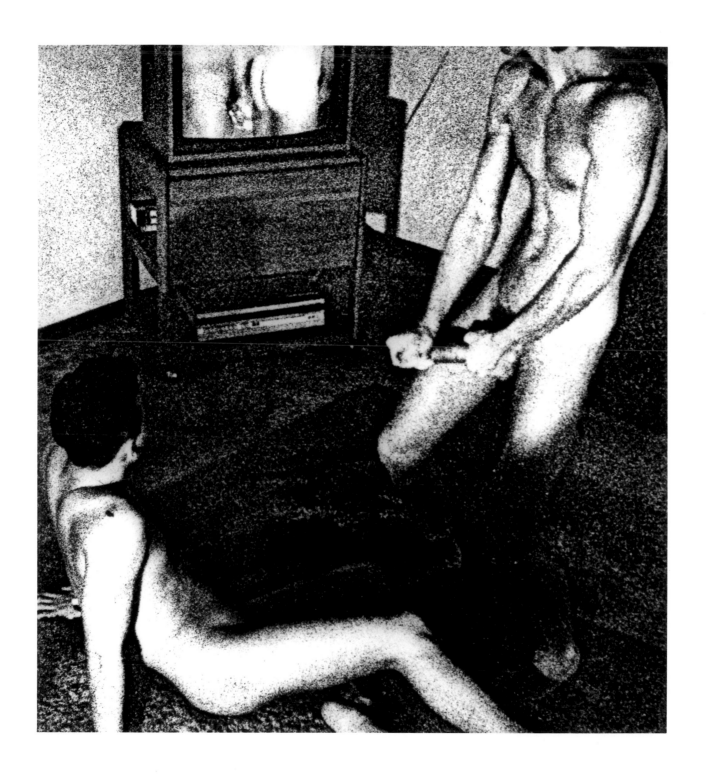

IMAGES CREATED TO EROTICIZE SAFE SEX FOR EDUCATIONAL PURPOSES, Chicago, IL, 1987

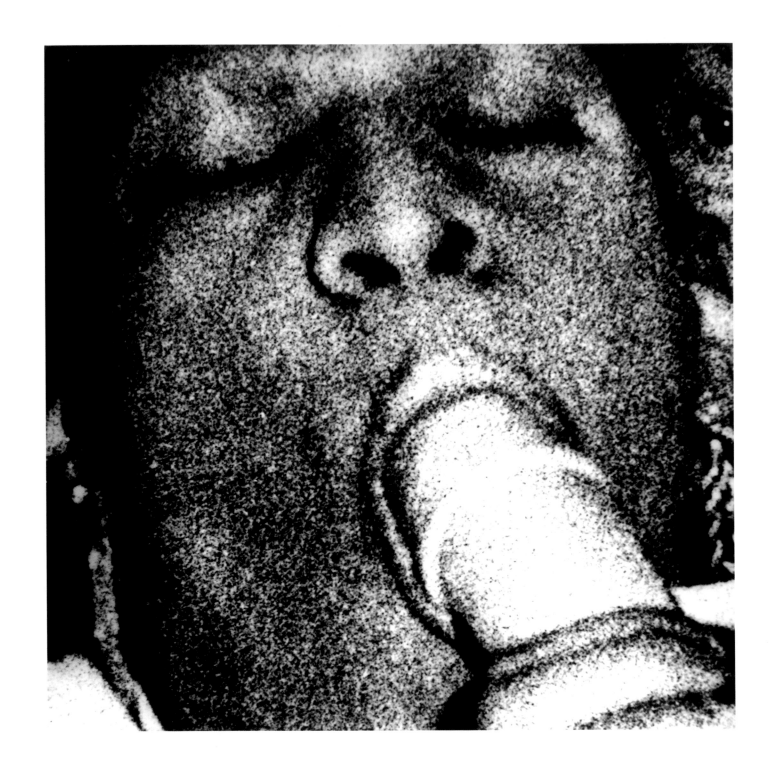

TRANSVESTITE SAFE-SEX OUTREACH WORKER, Santo Domingo, Dominican Republic, 1987

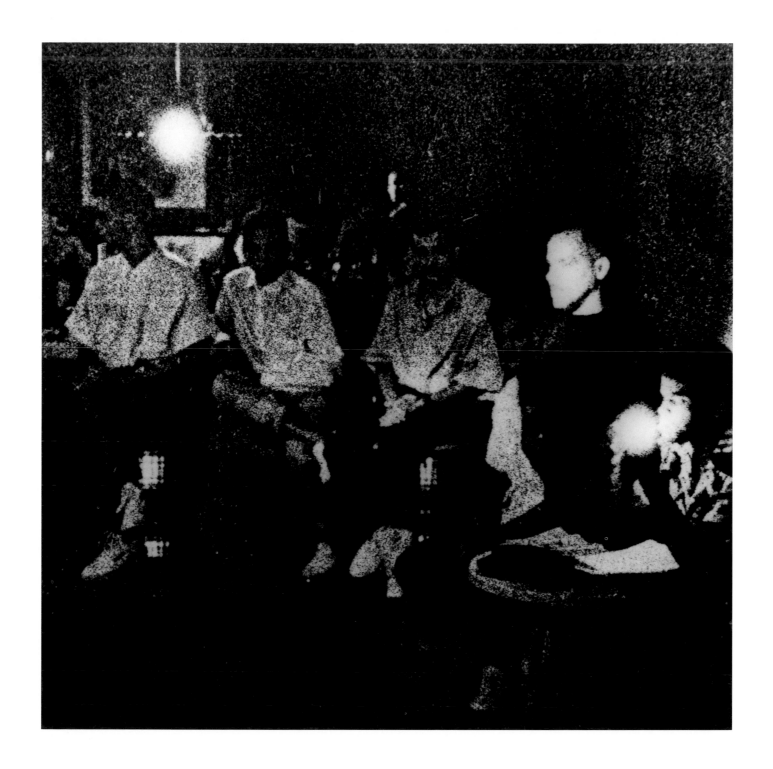

CESAR TEACHING SAFE SEX IN A GAY BAR, Santo Domingo, Dominican Republic, 1989

In Latin America, due to societal attitudes and prejudices, few men feel comfortable acknowledging that they have sex with other men, and therefore there is a big demand for transvestite sex workers. AIDS prevention must take the form of creative, culturally sensitive education programs. One such program, using transvestites as outreach workers, was implemented by the

DOMINICAN REPUBLIC

Academy of International Development in Santo Domingo. These outreach workers, trained to inform couples of safe-sex practices, visit areas frequented by sex workers, attach dildos to trees or to cars using suction cups, and look for sexually active couples. They then supply the couples with condoms and demonstrate their application on the dildos. This seems to be the most direct method of reaching men of all sexual orientations. As for medical treatment in the Dominican Republic, if someone tests HIV positive in a public hospital, he or she will be thrown out, and the only hope is to be able to afford a private doctor. As AIDS is disparagingly identified in the Dominican Republic as a "gay disease," a person with AIDS is almost always shunned by his or her family as well.

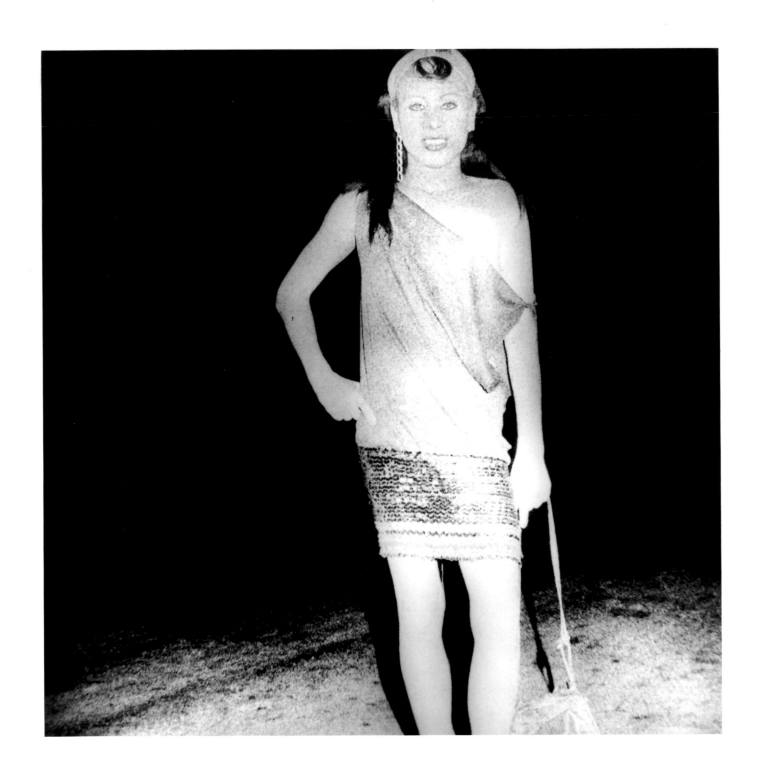

TRANSVESTITE SAFE-SEX OUTREACH WORKER, Santo Domingo, Dominican Republic, 1987

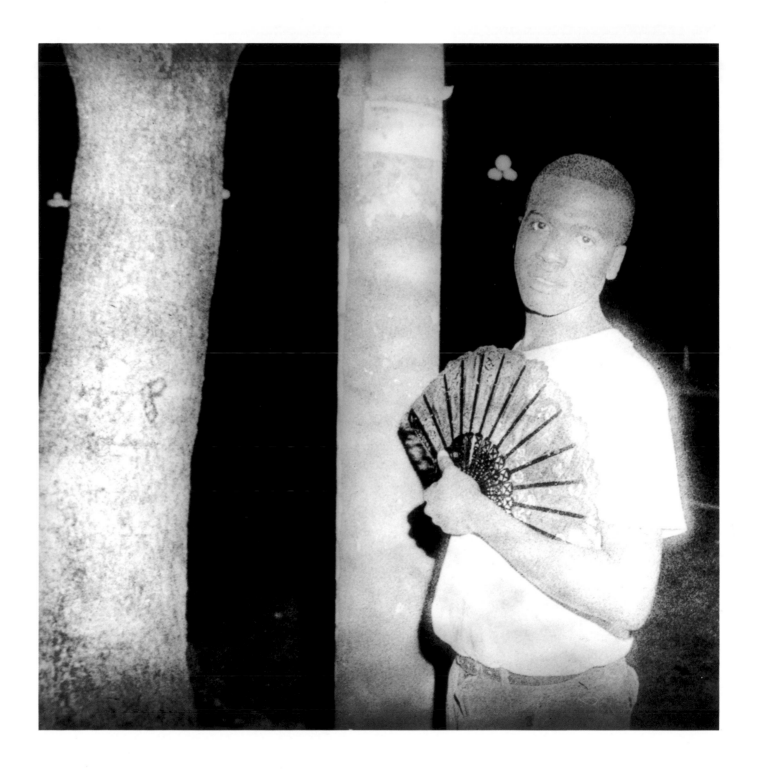

SAFE-SEX OUTREACH WORKER, Santo Domingo, Dominican Republic, 1987

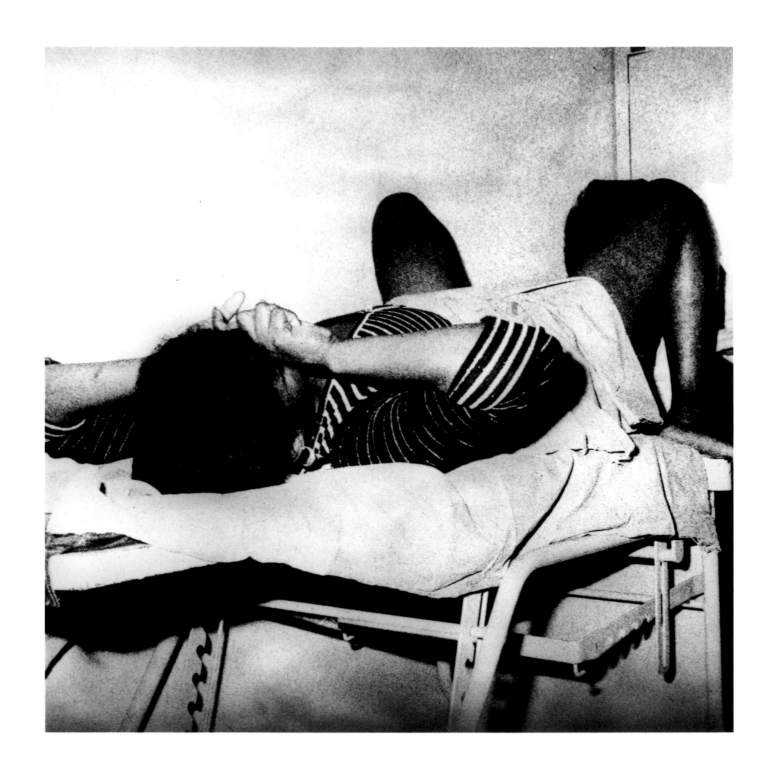

VAGINAL EXAM OF SEX WORKER, Santo Domingo, Dominican Republic, 1987

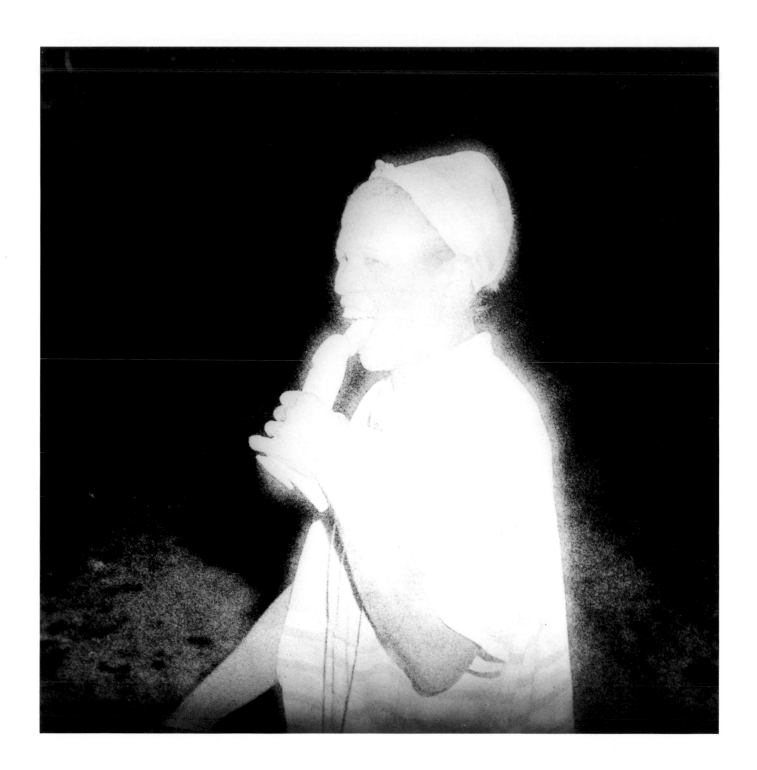

SAFE-SEX OUTREACH WORKER, Santo Domingo, Dominican Republic, 1987

Bangkok is considered by many to be the sex capital of the world. The city is full of Australians, Germans, and Japanese who come to Thailand on "sex holidays." Pat Pong Street is renowned for its young prostitutes and its acrobatic live sex shows. During the Vietnam war, Pat Pong functioned as a popular rest and relaxation center for U.S. servicemen.

Prostitution has a long history in Thai culture and is found in every stratum of society. In desperately poor farming villages in the northern hills, men trade rice for the services of boys and girls. With literally hundreds of thousands of prostitutes throughout the small country, services range in cost from sixty U.S. dollars to forty cents.

THAILAND

The HIV risk is directly correlated to the price of the prostitute. A girl receiving forty cents per client in a working-class brothel might service up to 3,000 partners over a year's time in order to make a living. Over 60 percent of sex-workers at this level in Thailand are HIV positive. The female prostitutes are so often infected and reinfected with venereal disease that they have constant genital sores, as do the men who hire them. These sores are symbols of manhood among many young Thai men. The sores are also perfect vectors for the spread of HIV: infected men in turn go home and infect their wives.

On the other hand, the boys around Pat Pong who service men have one of the lowest rates of HIV in Bangkok. As in many other countries, the gay male community in Thailand has organized and educated itself. This is not the case, however, with the lesbian community. Although this is generally a tolerant culture, the nonjudgmental quality of the Thai people ends when

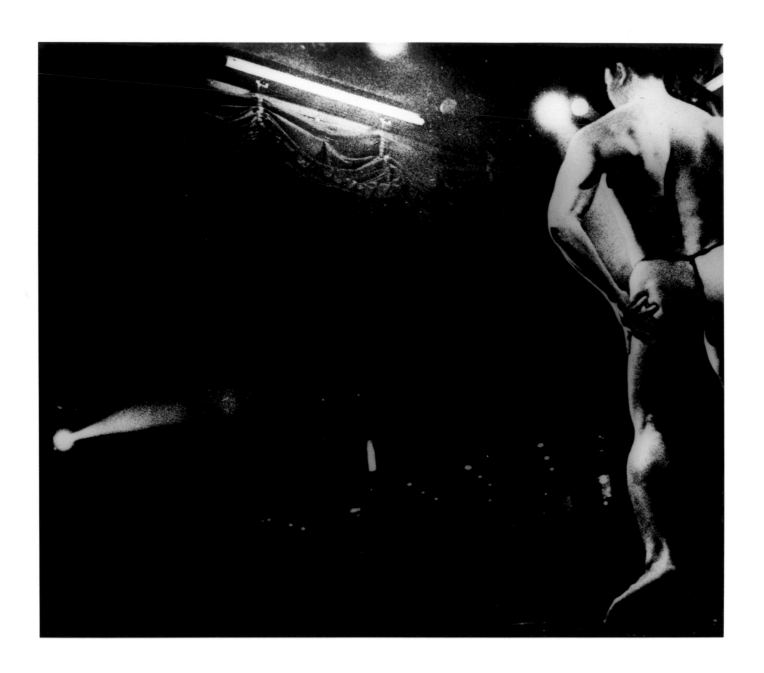

SEX WORKERS PARTICIPATING IN BODYBUILDING EXHIBITION, Bangkok, Thailand, 1989

SEX WORKER, Bangkok, Thailand, 1989

it comes to sex between women. When I was there, the one lesbian club in Bangkok had just been closed down. Now lesbians have to go to the same places that men go to in order to pick up girls. Therefore the risk of HIV infection for lesbian women is much higher in Thailand than it is elsewhere.

Heroin is the other major factor in the spread of AIDS in Thailand, and was probably the vehicle by which the disease first entered the country. Because of its proximity to the Golden Triangle, Thailand has some of the cheapest and purest heroin in the world. In New York City, heroin is 3 to 5 percent pure; in Thailand it is 90 to 95 percent pure. Because the heroin is so pure, and so inexpensive, Thailand is full of addicts from all over the world. It is through these foreign addicts sharing needles with the large number of Thai drug users that HIV infection has spread throughout the country. In some areas of urban poverty, the addiction rate is 40 percent of all teenagers, 50 percent of whom are already HIV positive.

AIDS in Thailand is now at a unique stage. Although there are hundreds of thousands of people who are HIV positive, there have only been thirty-four reported cases of full-blown AIDS as of 1989, when these pictures were made. With the long dormancy period before symptoms appear, and the fact that the AIDS virus was relatively recently introduced in Thailand, there have not been enough symptomatic cases to date to alarm the population. Epidemioligists foresee the possibility of 10 to 15 percent of the Thai population becoming infected if serious intervention and AIDS education does not begin soon.

SEX WORKER (PAT PONG STREET), Bangkok, Thailand 1989

GO-GO BAR, Bangkok, Thailand, 1989

SEX WORKER, Chiang Mai, Thailand, 1989

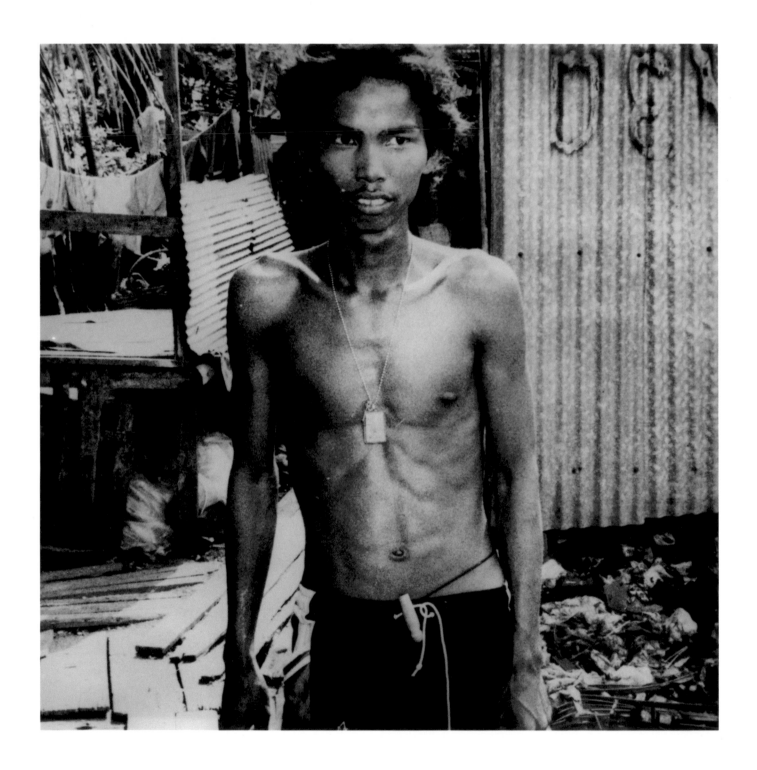

HEROIN ADDICT, KLONG TEOY SLUM, Bangkok, Thailand, 1989

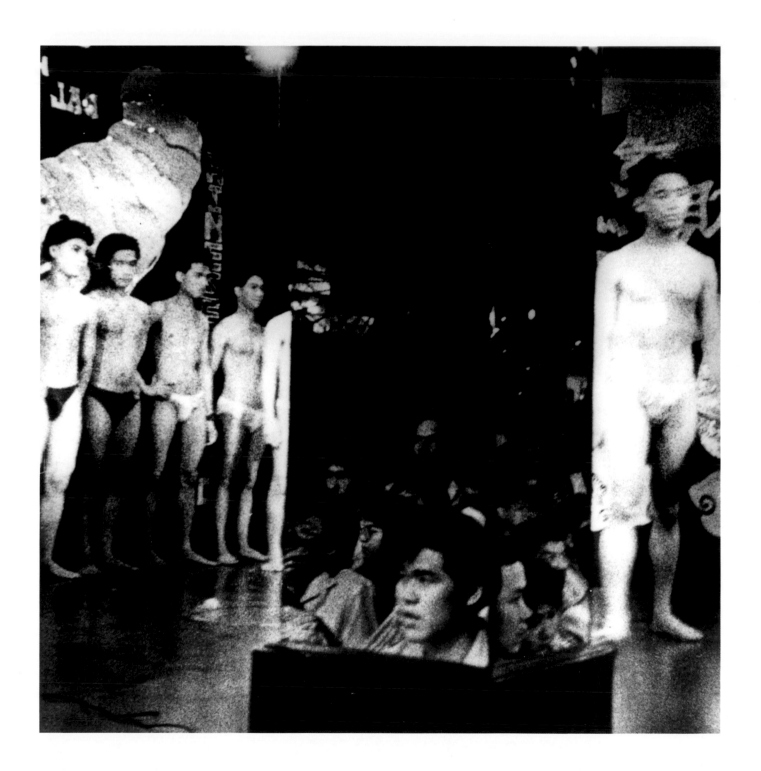

GO-GO BAR, Bangkok, Thailand, 1989

On the road to Pétionville, in Haiti, a large hand-lettered sign states: "AIDS is not an incurable disease. Dr. Daniel C. Claude." An arrow points down into a ravine with a cluster of houses at the bottom. I found Dr. Claude sitting in a cinder-block house just large enough to accommodate a double bed and large color TV. It was two in the afternoon, and he was sitting on the bed watching magic shows from France.

Dr. Claude claims to have cured hundreds of people with AIDS. He believes that AIDS has ten stages of illness, and if he meets a patient before stage seven-and-a-half, he can cure him or her. Dr. Claude can undoubtedly treat some of the illnesses associated with the virus with his various roots, weeds, and barks. His approach to the treatment of AIDS is not unlike that of Western medicine—treating the symptoms, not the virus itself. Dr. Claude had a file

HAITI

of negative HIV results from the Cornell University research program in Port-au-Prince. These were people Dr. Claude claimed to have cured, although there were no corresponding initial positive test results.

Haiti is the poorest nation in the Western Hemisphere: 50 percent of its population is unemployed with no hope of finding work; 60 percent of the country has no access to clean drinking water. According to doctors Glen Margo and John-David Dupree, Haiti also has "one of the highest per capita incidences of AIDS in the world. Though Haiti had reported nearly 3,000 cases as of December 1989, its surveillance system has been unable to keep up with new cases; thus, no new cases have been reported since then. Mother Teresa's two 'Homes for the Dying'—one pediatric and one adult— are filled with HIV-infected children and adults, many of whom simply don't have any other place to live." The country is an odd combination of the remains of French colonialism and a dominant African culture. A strong belief in voodoo and primitive medicine is still prevalent in most of the

population. It is not uncommon for Haitians living in the United States who become sick with AIDS to return to Haiti to seek the services of a medicine man or voodoo priest. Yet doctors Margo and Dupree say that "none of the cures or vaccines" put forth by these traditional healers have been "adequately documented to warrant any global or regional scientific optimism about their effectiveness."

Virtually no Western medicine is available to most of Haiti's population, and whatever medicine does exist is always questionable. The U.S. Food and Drug Administration only regulates drugs for U.S. consumption. Many U.S. drug manufacturers sell out-of-date or improperly manufactured drugs to Third World countries. The use of these drugs is rampant and deadly. In Haiti, drugs are usually bought on the black market and are taken to a *picuriste*, or injection doctor. The *picuriste* is paid to inject the drug into the patient. By using contaminated needles, the *picuristes* also contribute to the spread of AIDS in Haiti.

Early in this epidemic, Haitians in the U.S. were identified as one of the largest "at-risk" groups. The U.S. government included Haitians on a list of people who should not give blood because of the possibility of their being HIV infected. This began a wave of discrimination similar to that focused on gay men and IV-drug users. Haitians suffered from this stigma for ten years, until 1989 when they began to fight back. In New York City, Haitians used the network of Creole newspapers and radio to organize one of the largest AIDS marches the city has ever seen. Just as rush hour began, thousands of Haitians walked over the Brooklyn Bridge into Manhattan, shutting down one of the busiest routes in and out of the city and closing most of lower Manhattan. Two days later, the Surgeon General removed Haitians from the list of at-risk blood donors.

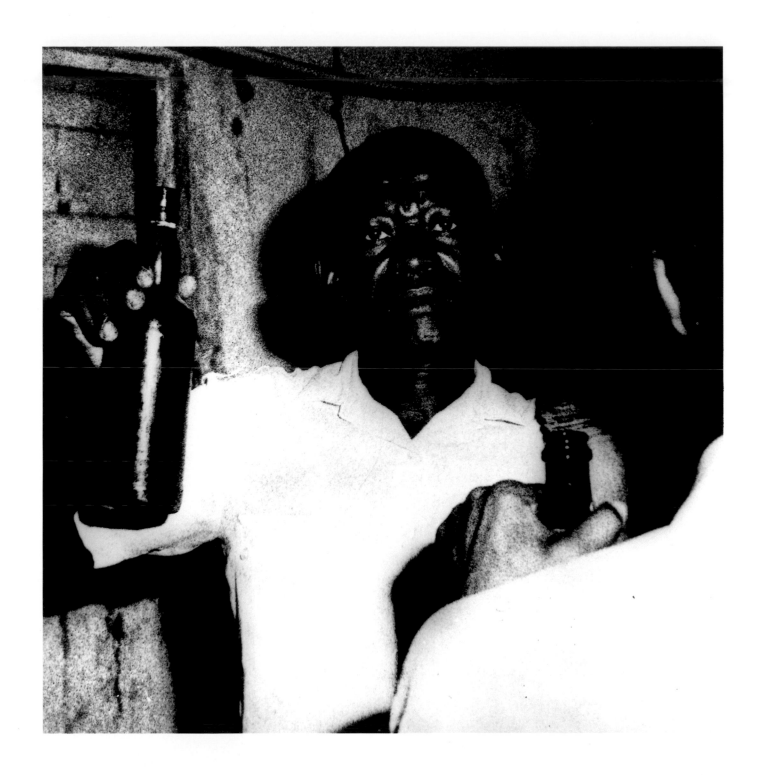

DR. CLAUDE, MEDICINE MAN, WITH HIS CURE FOR AIDS, Pétionville, Haiti, 1988

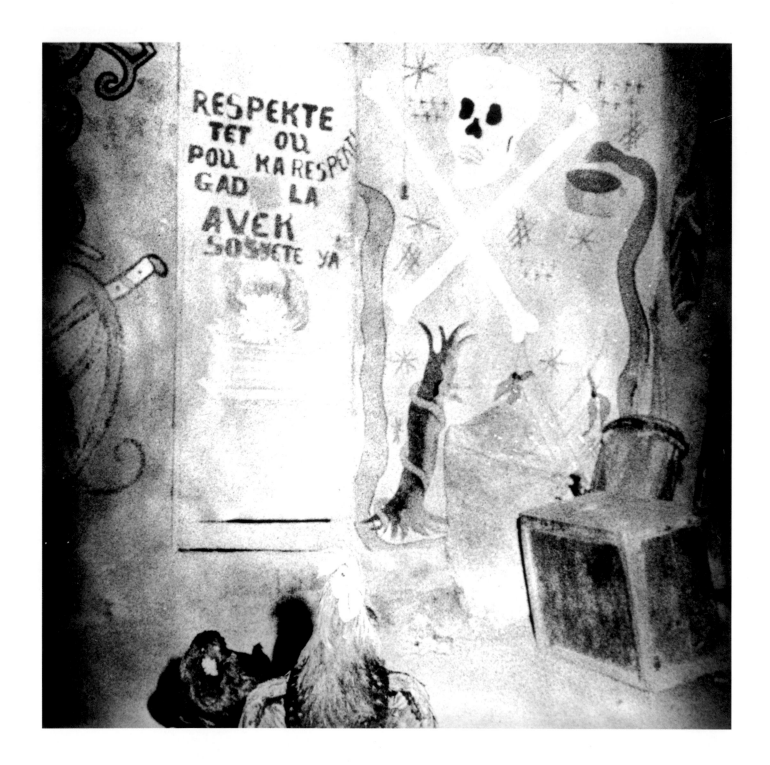

VOODOO TEMPLE WHERE PEOPLE WITH AIDS ARE TREATED, Cité Soleil, Haiti, 1988

VOODOO DRUG USED TO TREAT PEOPLE WITH AIDS, Cité Soleil, Haiti, 1988

In 1969, after one hundred years of colonial oppression, the blacks began a guerrilla war for freedom from Rhodesia. The Shona and Ndebele, two major tribes in Zimbabwe, have strong religious beliefs based on ancestor worship, and it is the religious leaders, or spirit mediums, who are possessed by the spirit and voice of the ancestors. The guerrillas of the revolution called themselves ZANU (Zimbabwe African National Union). These fighters realized that spirit mediums could be an efficient way of organizing the people, in that the mediums would be able to invoke the ancestors' desire that the oppression be ended at any cost, when the fighters needed to mobilize everyone. Because the blacks believed that their ancestors were directing them into battle against the whites, they fought fearlessly and with great conviction. The war was won, and Rhodesia became Zimbabwe in 1980. For the last ten years Robert G. Mugabe (the leader of ZANU) has been the president of Zimbabwe.

Even though the spirit mediums were the key to winning independence, Mugabe and his ZANU government have since abandoned the healers in

ZIMBABWE

hopes of bringing Zimbabwe into the twentieth century. Despite this desire to modernize the country, however, there is little access to, and a general distrust of, Western medicine. Since the revolution, a union of spirit mediums was formed and now has 350,000 certified members. Most of these spirit mediums are healers, and they provide the primary medical care for 85 percent of the population of Zimbabwe.

In traditional healing, diagnosis is a process of throwing bones that land in patterns and convey to the healer the cause of an ailment. Illness is believed to be brought about by witches or a disapproving ancestor. The healing approach is always holistic: the patient's entire family is involved in the treatment, which is both medicinal and spiritual, treating not only the patient but the family unit and community. Drugs called *moodies* are made from roots, leaves, and other substances found in the bush. Through dreams and trances, the healer is directed by the ancestors in the preparation of the *moodies*.

When it is time to treat the patient, a razor cut is often made to open a vein and the *moodie* is rubbed directly into the bloodstream. Traditional healers can cure most intestinal illnesses, which are common in Africa. They are able to categorize, diagnose, and treat fifteen types of diarrhea.

Most mediums can also cure more complex illnesses, such as malaria and tuberculosis. Midwives are often spirit mediums as well. Their array of *moodies* can treat everything from infertility to prenatal care to labor inducement, as well as providing pain relief. In rural areas, these midwives also deliver 95 percent of all children.

With the advent of the AIDS crisis, there was concern in Zimbabwe about the healers' methods of treatment: the frequent direct contact with the patients' blood in applying the *moodies* allowed for easy transmission of the virus. Now, with a better understanding of how AIDS is spread, the healers have begun to educate their patients about the disease. But, as in this country, it is only the symptoms that are being treated, not the virus itself. The spirit mediums also play an integral part in the emotional counseling of the patients' families during the illness, and in helping them to come to terms with death.

Besides traditional healers, others have made efforts to educate Zimbabwe about AIDS. Since his appointment several years ago, Health Minister Dr. Timothy J. Stamps has begun what he calls a "cultural revolution," which includes education about safe sex. An April, 1992 article in *The New York Times* reported that in 1986, 500,000 condoms were distributed in Zimbabwe; for 1992, the projected use is 65 million. Condoms are now available free in all government health clinics and family-planning clinics. They are also sold in night spots and restaurants.

In the schools, children as young as eleven receive instruction about AIDS. Quoted in the *Times*, Stamps said he sees evidence that teenagers may now be "more modest in their sexual behavior," but noted a countervailing trend perhaps more alarming: promiscuous older men often favor teenage girls as sexual partners because they believe they are less likely to be HIV positive. Soon, Stamps told the *Times*, Zimbabwe "may be looking at what has happened in Uganda, where a girl at eighteen is three times as likely to be HIV positive as a boy."

If Stamps is unsuccessful in his "cultural revolution," and there are no changes in the nation's sexual behavior, demographic studies predict that by 2017, when Zimbabwe's population is expected to reach 18 million, the number of births and the number of deaths from AIDS will be equal.

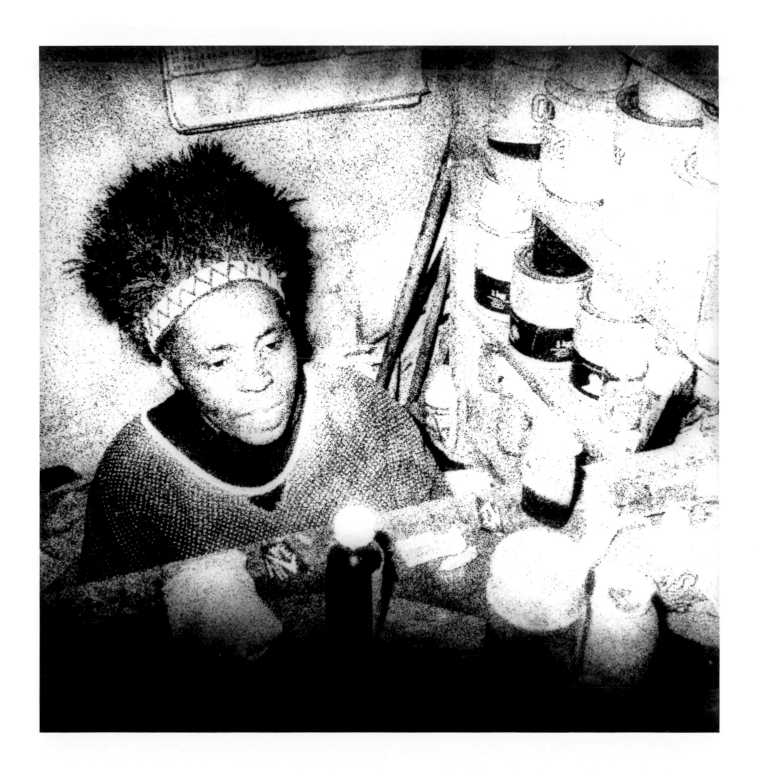

MIDWIFE AND TRADITIONAL HEALER, Bulawayo, Zimbabwe, 1990

SPIRIT MEDIUM, Harare, Zimbabwe, 1990

ZIMBABWE ARMY, 30 PERCENT HIV POSITIVE, Harare, Zimbabwe, 1990

In 1990, the summer I was in South Africa, I met a lot of AIDS educators and people who were working on the health platforms for the African National Congress. There are no government programs for people with HIV in South Africa, and it's unlikely that there ever will be. At the same time, AIDS is manifesting itself as an epidemic that is directly related to the social and political structure of the country. The apartheid system and the lifestyles it has determined are significant when examining the spread of the AIDS virus.

The development of townships and homelands miles away from any source of work creates a large black population of migrant laborers separated for long periods of time from their families. Contractual labor is still common for many black workers. Historically, miners have always had to sign two-year contracts. (In former times, contract breaking was punishable by imprisonment.) Black miners (unlike whites) are not allowed to bring their families to live with them. They are made to live in single-sex hostels provided by the employer until the first year of the contract is finished. They may then go home for four weeks before returning to the mines.

SOUTH AFRICA

The conditions in the hostels and in the mines are some of the harshest imaginable. Alcohol and sex are often the only releases from the terrible loneliness of this life. The mining companies seem to encourage both, as they are quick ways for miners to spend money, thus forcing them to sign new contracts and remain indentured. Homosexual relationships often develop among men, who eventually go home to their wives. There are what are known as "mine marriages," in which men couple. If you asked them if they were gay they would probably kill you, but it is quite clear that these men are in very defined pairs.

The women left behind in the townships and homelands often have secondary partners as well, so if the men are not infecting the women then the women may infect the men—all because of the lives they are forced to lead. Due largely to this frequency of multiple-partner sexual relations on the part of both men and women, AIDS has developed in South Africa as a disease primarily affecting heterosexuals.

The Chamber of Mines in South Africa now tests all workers at the beginning of each new contract. In 1989, 12 percent of the workers from Mozambique were HIV positive. One year later it had risen to 20 percent. If they test positive, workers are sent home and their names are placed in a centrally accessed computer that will bar them from employment in any South African mine. Attempts by mining companies to educate workers about

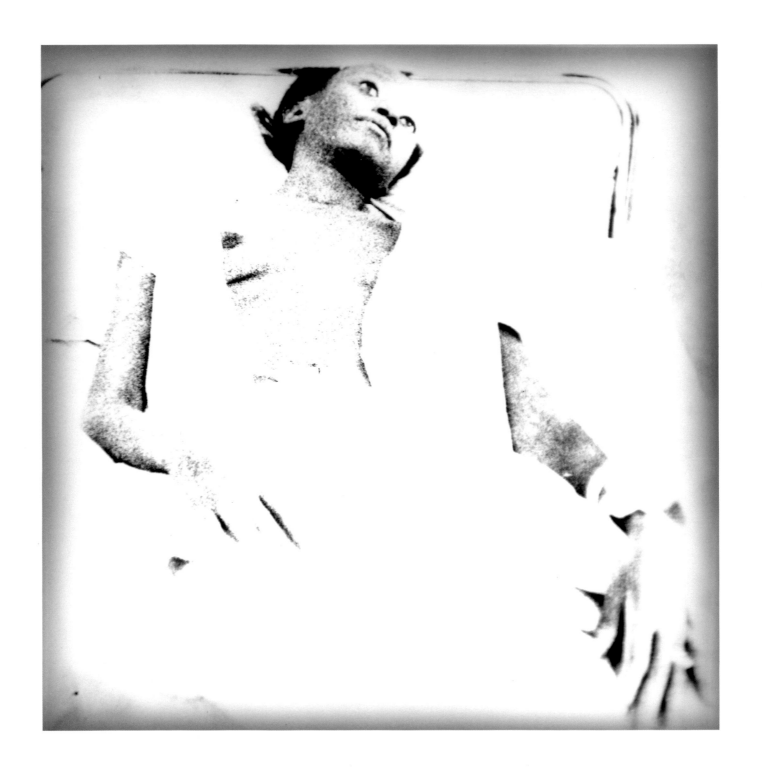

WOMAN WITH AIDS AT BARAGWANA HOSPITAL, Soweto, South Africa, 1990

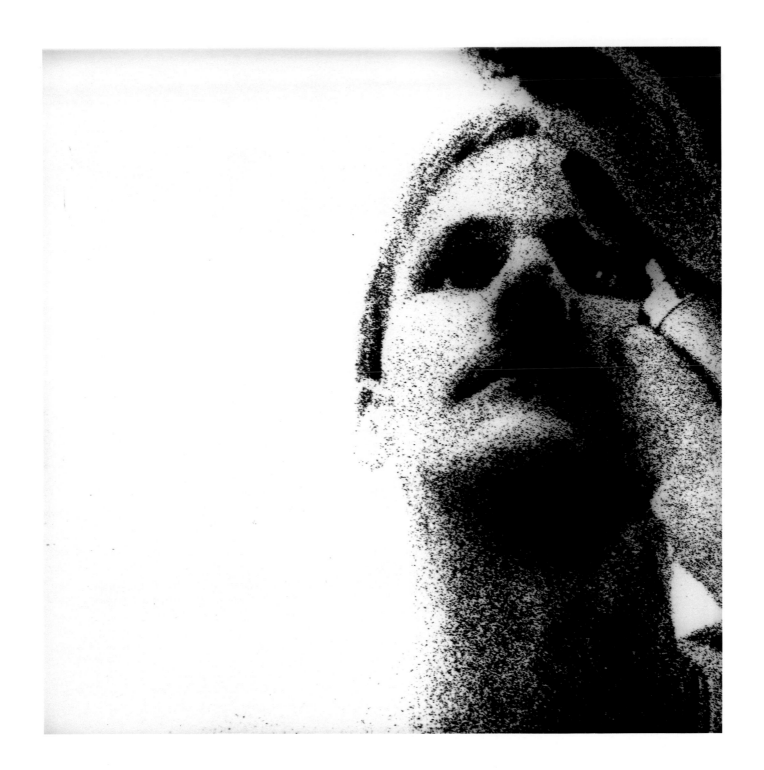

JAN AND DR. STEVEN MILLER, Johannesburg, South Africa, 1990

safe sex have generally failed. The unions could provide effective education, but their access to the mines is limited. Domestic and factory workers, agricultural and general service providers also live where they work, returning home once a week or once a month.

Until recently, health care in South Africa was racially segregated. Baragwana Hospital is the black hospital servicing Soweto. It is the largest hospital in Africa. It is so overcrowded that people sleep under beds, in chairs, and in hallways. In 1984 an open letter was sent by some of the doctors and residents of Baragwana to the South African government. The letter stated that Baragwana was underfunded and understaffed, and that the level of medical care was inhumane. The government was so angered by the letter that they threatened to close the hospital. The doctors who signed the letter were never promoted within the hospital, and the majority of the residents were prevented from graduating.

Liz Floyed is a white South African doctor. Like many other antiapartheid advocates, she has a history of deep political commitment and intense suffering. She and her husband were both doctors committed to providing adequate health care for blacks in the townships. This was seen by the government as political subversion. They were both picked up by the authorities, although they were not formally charged; Liz was forced to spend the next two years in detention, and was not allowed contact with her family. Upon her release, she learned that her husband had been beaten to death shortly after their arrest.

Today Liz is married to a black lawyer and has a three-year-old daughter. She is beginning to see large numbers of AIDS patients in her clinic in Soweto. The highest-risk group in Soweto is a group called the "young comrades," soldiers in the struggle against apartheid. They are fiercely dedicated to the freedom fight in the face of death, torture, and detention. They are also very young and sexually active. As there is little (if any) education regarding safe sex and AIDS, they are becoming infected with HIV in alarming numbers. Liz's greatest fear is that the intensity of the fight for liberation will not allow for AIDS education at this critical time. It must be made clear to the comrades that AIDS is a disease that plays into the hands of those supporting the goals of the apartheid system. If safe-sex education is not translated into the politics of liberation, vast numbers of black South Africans will be lost at a time when numbers are a crucial factor.

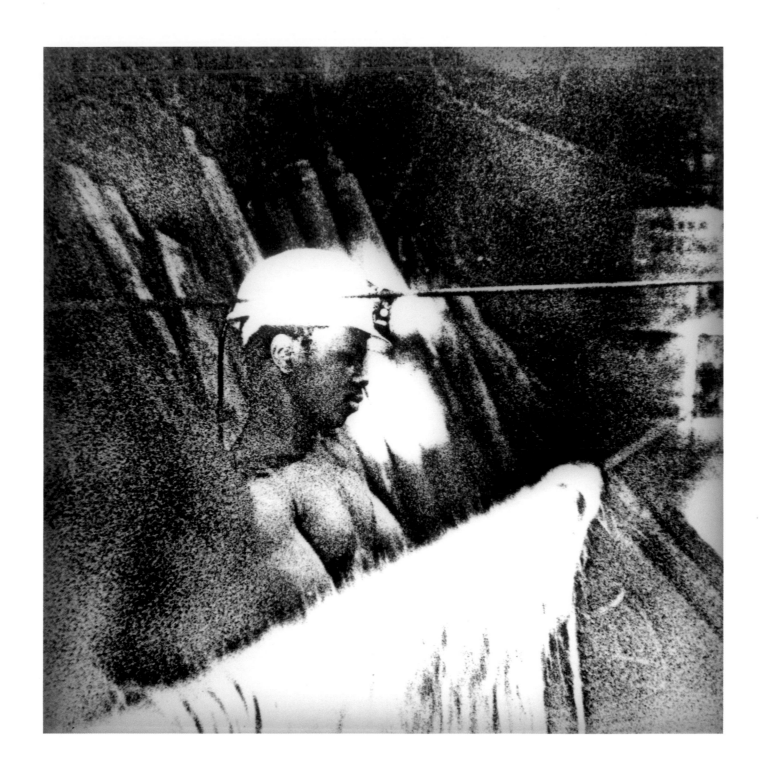

GOLD MINER, Johannesburg, South Africa, 1990

GOLD MINER BEING SENT HOME AFTER TESTING POSITIVE FOR HIV, Johannesburg, South Africa, 1990

MEN SHOWERING TOGETHER IN MINING COMPOUND, Johannesburg, South Africa, 1990

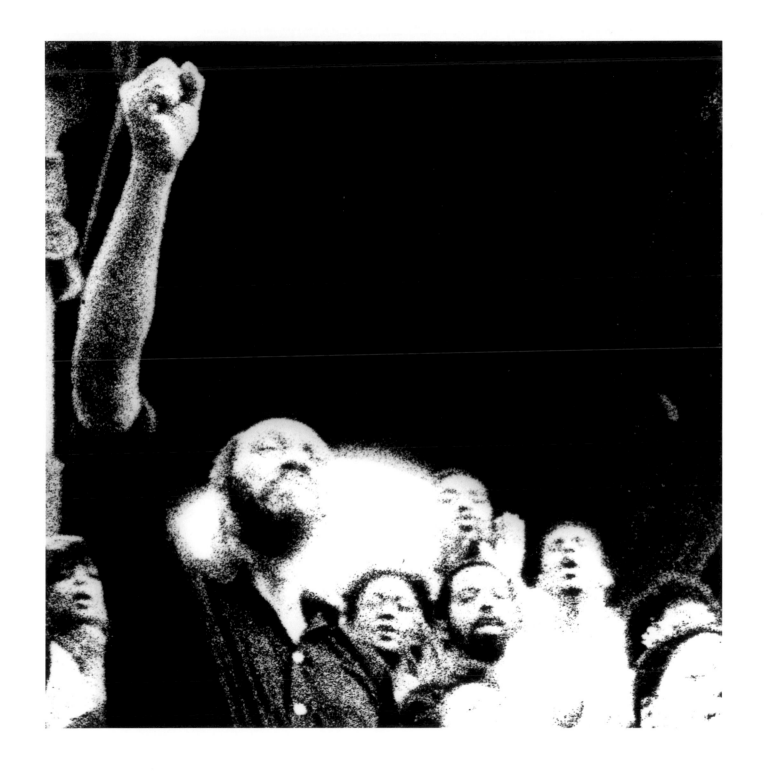

GOSPEL CHOIR FROM BROOKLYN METHADONE CENTER, SINGING AT AIDS MEMORIAL, Brooklyn, NY, 1987

Library of Congress Catalog Card Number: 92-70291
ISBN: 0-89381-524-1

Book design by Bureau, New York
Composition by V&M Graphics
Printed and bound by South China Printing Co. Ltd., Hong Kong

The staff at Aperture for *Every 17 Seconds: A Global Perspective on the AIDS Crisis* is Michael E. Hoffman, Executive Director; Melissa Harris, Editor; Michael Sand, Managing Editor; Suzan Sherman, Annie Wiesenthal, Editorial Work-Scholars; Stevan Baron, Production Director; Sandra Greve, Production Associate.

Aperture wishes to thank the following people for their input and assistance: Phil Block, Buzz Hartshorn, David Hirsh, Charles V. Miller, and especially Dr. Stephen W. Nicholas.

First edition
10 9 8 7 6 5 4 3 2 1